SCENES *of* AMERICAN LIFE

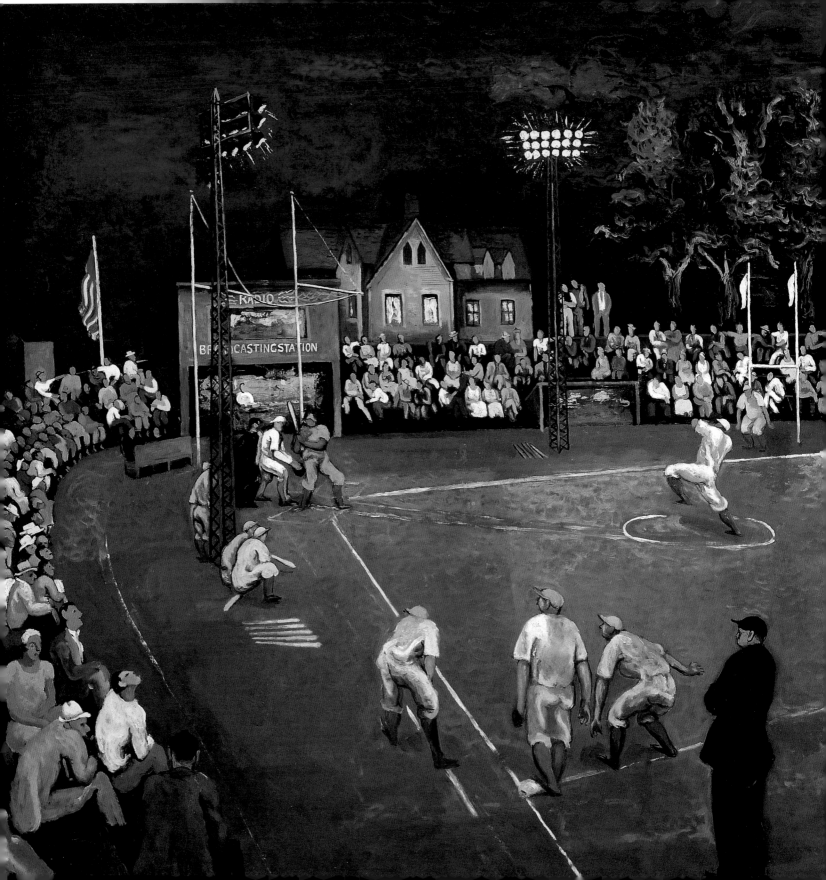

SCENES of AMERICAN LIFE

Treasures from the
Smithsonian American Art Museum

Elizabeth Prelinger

Watson-Guptill Publications/New York

Smithsonian American Art Museum

Scenes of American Life: Treasures from the
Smithsonian American Art Museum

By Elizabeth Prelinger

Chief, Publications: Theresa Slowik
Designers: Steve Bell, Karen Siatras
Editor: Mary J. Cleary

Library of Congress Cataloging-in-Publication Data

Smithsonian American Art Museum
 Scenes of American life : treasures from the
Smithsonian American Art Museum /
Elizabeth Prelinger.
 p. cm.
Includes index.
 ISBN 0-8230-4654-0
 1. Art, American—Exhibitions. 2. Art,
Modern—20th century—United States—Exhibi-
tions. 3. United States—In art—Exhibitions.
4. United States—Social life and customs—Exhibi-
tions. 5. Art—Washington (D.C.)—Exhibitions.
6. Smithsonian American Art Museum—Exhibi-
tions. I. Prelinger, Elizabeth. II. Title.
 N6512.S63 2001
 758'.997391'074753—dc21
 20-01000356

Printed and bound in Italy

First printing, 2001
1 2 3 4 5 6 7 8 9 / 08 07 06 05 04 03 02 01

© 2001 Smithsonian Institution
First published in 2001 by Watson-Guptill
Publications, a division of BPI Communications,
770 Broadway, New York, NY 10003, in association
with the Smithsonian American Art Museum.

Cover: Edward Hopper, *Cape Cod Morning,* 1950, oil.
Smithsonian American Art Museum, Gift of the
Sara Roby Foundation (see page 50).

Frontispiece: Morris Kantor, *Baseball at Night* (detail),
1934, oil. Smithsonian American Art Museum, Gift
of Mrs. Morris Kantor (see page 58).

Scenes of American Life is one of eight exhibitions in *Treasures to Go,* from the Smithsonian American Art Museum, touring the nation through 2002. The Principal Financial Group® is a proud partner in presenting these treasures to the American people.

Foreword

Museums satisfy a yearning felt by many people to enjoy the pleasure provided by great art. For Americans, the paintings and sculptures of our nation's own artists hold additional appeal, for they tell us about our country and ourselves. Art can be a window to nature, history, philosophy, and imagination.

The collections of the Smithsonian American Art Museum, more than one hundred seventy years in the making, grew along with the nation itself. The story of our country is encoded in the marvelous paintings, sculptures, and other artworks we hold in trust for the American people.

Each year more than half a million people come to our home in the historic Old Patent Office Building in Washington, D.C., to see great masterpieces. I learned with mixed feelings that this neoclassical landmark was slated for renovations. Cheered at the thought of restoring our magnificent showcase, I felt quite a different emotion on realizing that this would require the museum to close for three years.

Our talented curators quickly saw a silver lining in the chance to share our greatest, rarely loaned treasures with museums nationwide. I wish to thank our dedicated staff who have worked so hard to make this dream possible. It is no small feat to schedule eight simultaneous exhibitions and manage safe travel for more than five hundred precious artworks for more than three years, as in this *Treasures to Go* tour. We are indebted to the dozens of museums around the nation, too many to name in this space, that are hosting the traveling exhibitions.

The Principal Financial Group® is immeasurably enhancing our endeavor through its support of a host of initiatives to increase national awareness of the *Treasures to Go* tour so more Americans than ever can enjoy their heritage.

Scenes of American Life, written by Dr. Elizabeth Prelinger, conveys all the wit and color, muscle and grit of daily life in twentieth-century America. As the elegance and formality of the Gilded Age receded, writers and painters turned toward the common man and images of everyday Americans at work and play. Following the stock market crash of 1929, millions of Americans were out of work, but soon President Franklin D. Roosevelt's New Deal projects put many of them back to work, including hundreds of artists. Their paintings are no doubt colored by their own experience of unemployment, as well as the joy of being able to work at their calling. A diversity of views was expressed in government-sponsored artworks—paintings, sculptures, and murals for post offices, schools, and libraries throughout the country.

A sense of anxiety and alienation appears in many works as America enters the Cold War during the 1950s. In tumultuous times, Americans traditionally find stability in the land. As the century drew to a close, images of the land and its people continued to symbolize our ideals and identity.

The Smithsonian American Art Museum is planning for a brilliant future in the new century. Our galleries will be expanded so that more art than ever will be on view, and we are planning new exhibitions, sponsoring research, and creating educational activities to celebrate American art and understand our country's story better.

Elizabeth Broun
Margaret and Terry Stent Director
Smithsonian American Art Museum

MARVIN BEERBOHM

1908–1981

Automotive Industry

1940, oil
198.1 x 467.4 cm
Smithsonian
American Art
Museum, Transfer
from the Detroit
Public Library

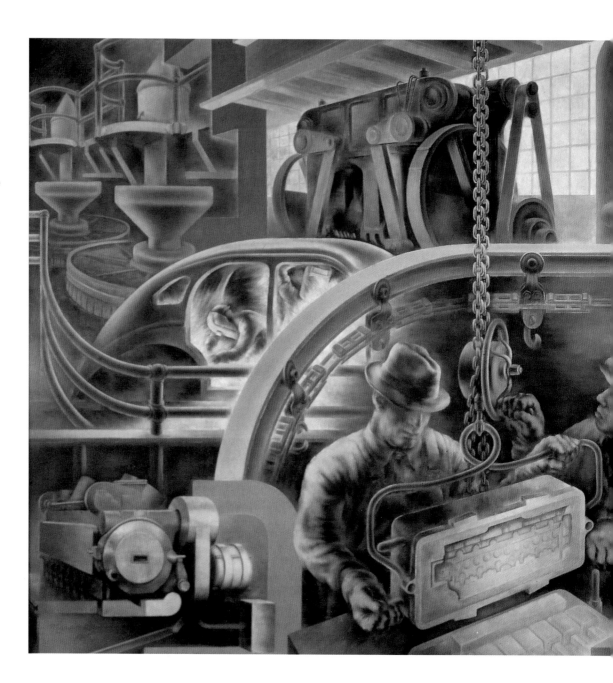

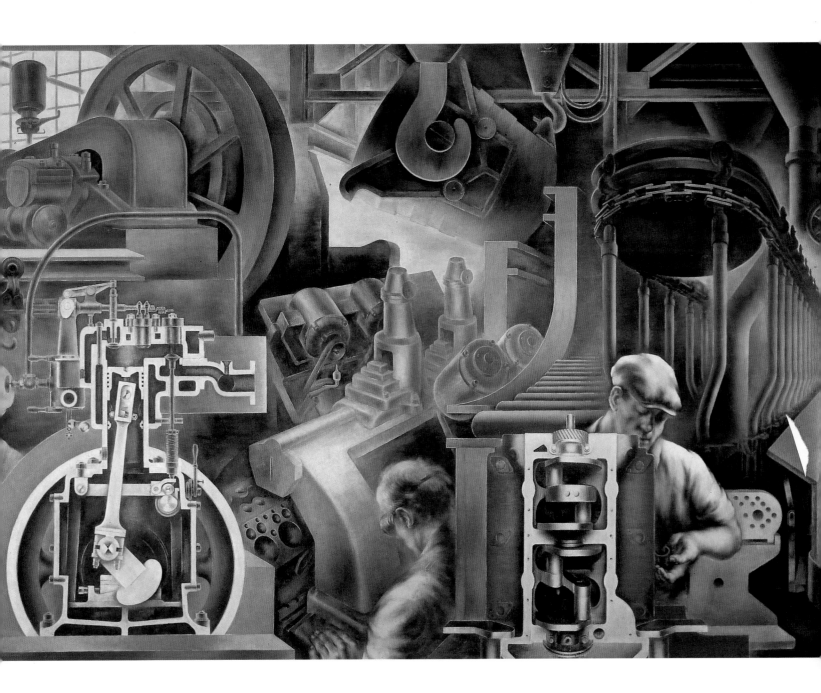

THOMAS HART BENTON

1889–1975

Wheat

1967, oil
50.8 x 53.3 cm
Smithsonian
American Art
Museum, Gift of Mr.
and Mrs. James A.
Mitchell and
museum purchase

Row by row, neatly arranged stalks of wheat, emblematic of the democratic masses of America, march into the distance. Two rows have been harvested but the land already exhibits new growth that promises to be as rich with grain as the plants that rise above them. One broken stem seems a symbol of impending mortality amid the pulsing energy of the field. The rabbit's-eye view places us in the heart of nature's primal forces, making us participants in Benton's allegory of populism and democracy. Painted while Benton was recovering from a heart attack, the picture exemplifies the Missouri artist's preoccupation with themes of planting and harvesting, death and rebirth.

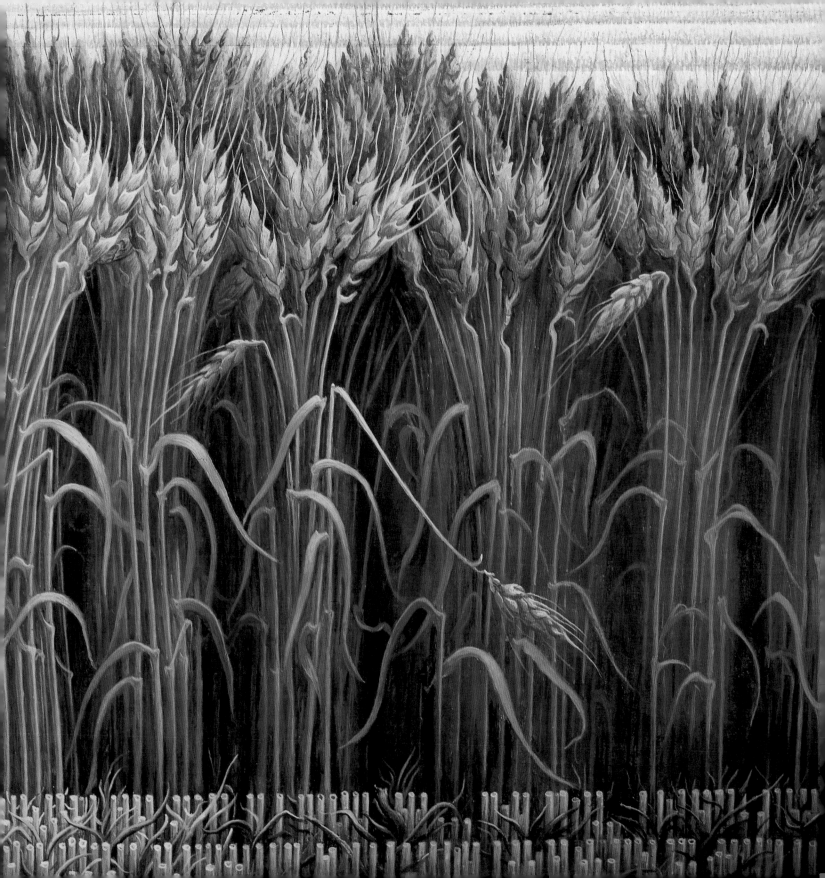

PETER BLUME

1906–1992

Vegetable Dinner

1927, oil
64.2 x 76.8 cm
Smithsonian
American Art
Museum

Elegant, mysterious, and erotic, *Vegetable Dinner* combines still life, landscape, and figure painting. Complex formally, it is simultaneously charged with psychological overtones. Blume activates a set of angles in the pattern of the woman's dress, uptilted table, and in the sails and houses seen through the window. To these sharply defined geometries he opposed the pulsing presence of the squash and carrots, with their obvious female and male forms. The taut realism of the image is shattered by odd, disturbing passages such as the paring knife wielded by disembodied arms and hands, terrifyingly poised to slice through the peeler's thumb. Within a simple kitchen conversation, we sense a moment fraught with unspoken tension and anxiety.

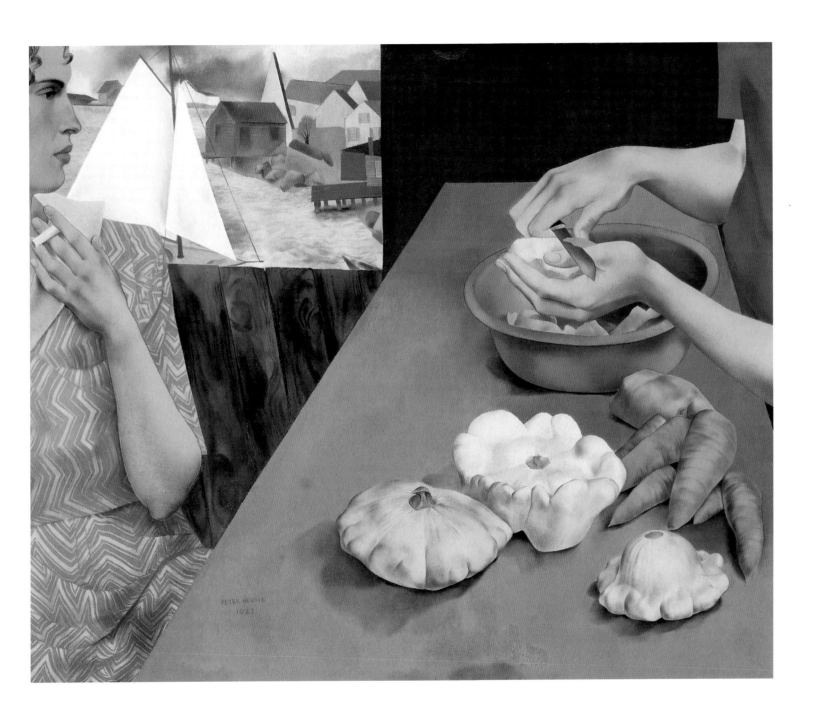

PAUL CADMUS

1904–1999

Aspects of Suburban Life: Golf

1936, oil and
tempera
80.6 x 127 cm
Smithsonian
American Art
Museum, Transfer
from the U.S.
Department of
State

One of four gaudy panels depicting contemporary sports, *Golf* exhibits Cadmus's gift for acid satire, social criticism, and moral allegory. The middle-aged, vulgar, cigar-chomping golfers contrast with their two caddies, one representing youth, the other, age. The young caddy grasps a golf bag with a muscled arm, his vigor contrasting sharply with his paunchy employers. The elderly caddy replaces a club—is this what the youth will become? Cadmus's worm's-eye view forces us, along with the young caddy, to look up at this wincing portrait of suburban ease, with its implied excess and soft waistlines. To heighten the parody, he depicts them in classical poses with theatrical gestures, linking them to Europe's tradition of grand history painting. Critic Lincoln Kirstein noted, "Swift, compact, dramatic, their atmosphere of cheerful parody was not so subtle as to prevent bureaucrats and taxpayers from feeling uneasy." Indeed, officials in the post office of Port Washington, New York—for which the suburban life series was commissioned—felt so uneasy that they turned it down.

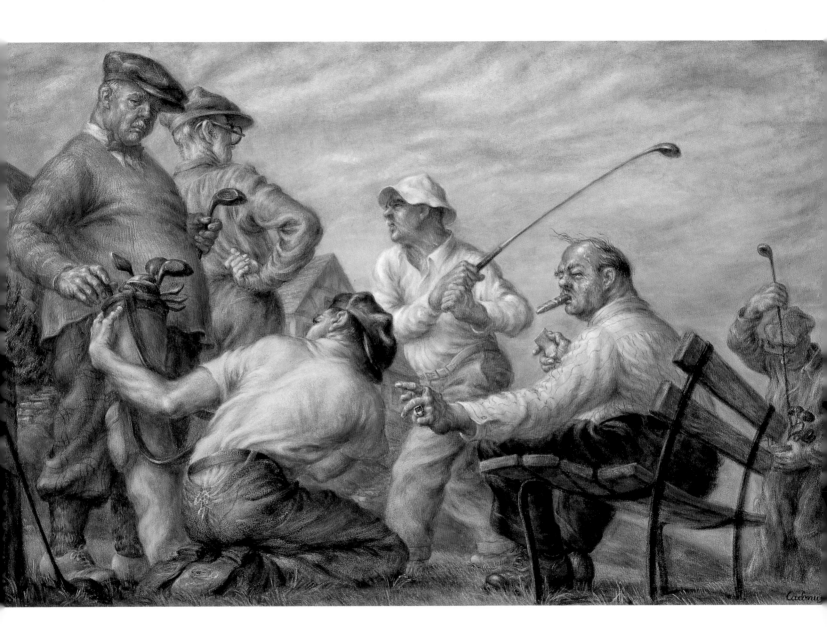

PEDRO CERVANTEZ

born 1915

View of the Artist's Home

1938, oil
51.1 x 81.2 cm
Smithsonian
American Art
Museum,
Transfer from
the General
Services
Administration

A wide-angle perspective invites us into the New Mexico home of Pedro Cervantez. We enter under a covered porch supported by simple pillars. Doors lead to the interior past a wooden chest flanked by a plant; a waterskin hangs from the post above a small, shelved stool with a pan on top. Beyond the fence, the landscape stretches into the distance.

Sharply angled and geometric, the scene possesses a clarity that links it to the work of such contemporary painters as Charles Sheeler, who were sometimes called precisionists. Like many Depression-era artists, Cervantez found work under the federally sponsored art programs of President Roosevelt's New Deal. This picture was commissioned for the General Services Administration, where it remained until its transfer to the Smithsonian American Art Museum.

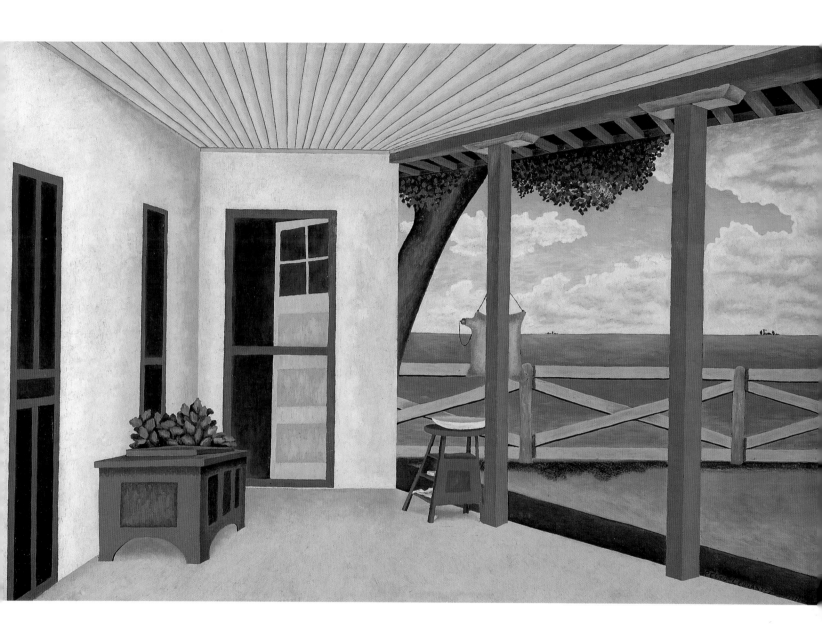

TYRONE COMFORT

1909–1939

Gold Is Where You Find It

1934, oil
101.9 x 127.3 cm
Smithsonian
American Art
Museum, Transfer
from the U.S.
Department of the
Interior, National
Park Service

Tightly wedged in the gloom of a mineshaft, a man hammers his drill into unforgiving rock. He jabs his foot against the tool to temper its violent jolting, stripped to the waist in the suffocatingly hot, close space. Comfort's use of harsh dark browns, with areas slashed with white to indicate the rock layers, underscores the physically and psychologically demanding nature of this job. The placement of the miner directly in the foreground, with no distance between him and the viewer, conveys the claustrophobic space of the mine shaft.

Such a dignifying of honest labor suits the commission: Comfort made the picture in 1934 for the Public Works of Art Project, the first of the government-supported New Deal art programs created during the Depression. When the twenty-six-year-old artist, then living in Los Angeles, completed this epic canvas, President and Mrs. Roosevelt selected it to hang in the White House.

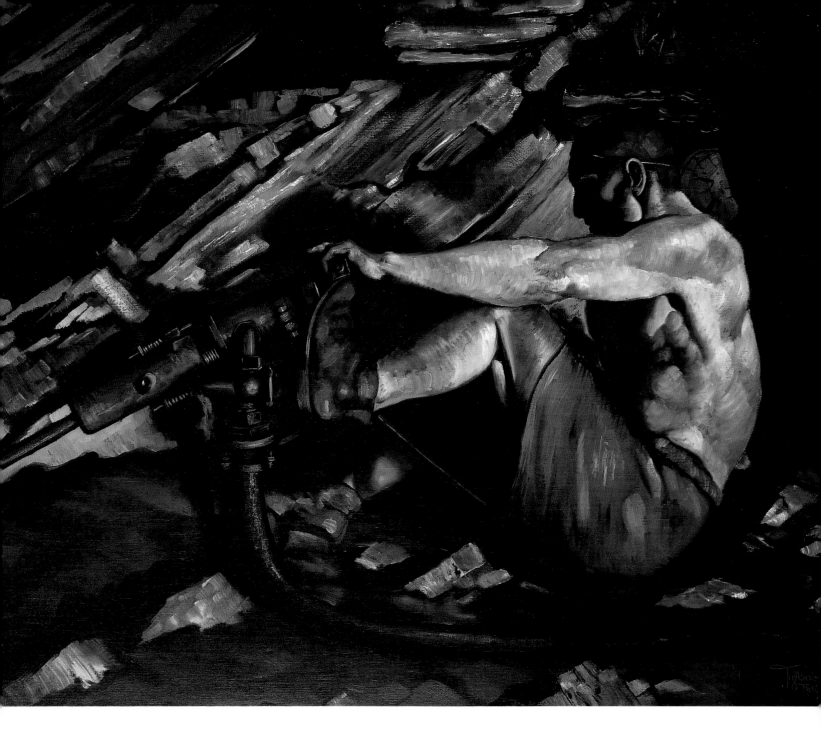

RALSTON CRAWFORD

1906–1978

Buffalo Grain Elevators

1937, oil
102.1 x 127.6 cm
Smithsonian
American Art
Museum

Buffalo Grain Elevators reveals the mythic beauty and formal purity of the American industrial landscape. Crisply modern in its linear style, taut angles, and vernacular American subject matter, the work celebrates heavy industry and the country's vast shipping networks. Painted in 1937 during the Great Depression, it offers the city's majestic silos as symbols of agricultural plenty in time of want.

Crawford, a native of Buffalo, New York, and a member of a group of artists called precisionists, was always fascinated by such industrial structures as bridges, factories, and grain elevators. In fact, Buffalo merchant Joseph Dart built the world's first grain transfer elevator in 1842, leading to the emergence of that city as the world's largest grain-shipping port. Buffalo preserved its elevators, and Crawford could study examples constructed from wood, steel, and concrete.

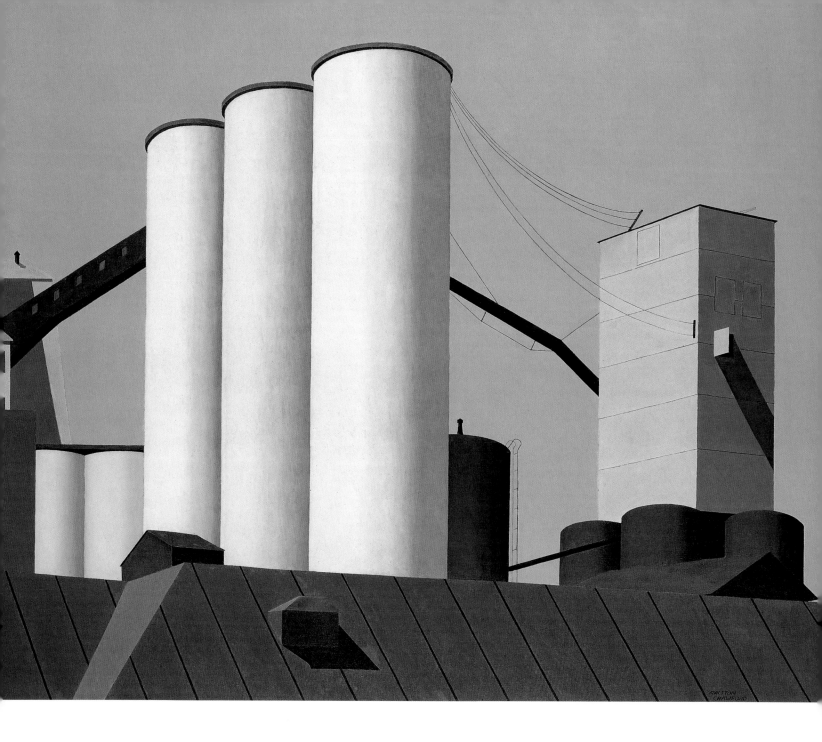

ALLAN ROHAN CRITE

born 1910

Sunlight and Shadow

1941, oil
64.2 x 99.1 cm
Smithsonian
American Art
Museum

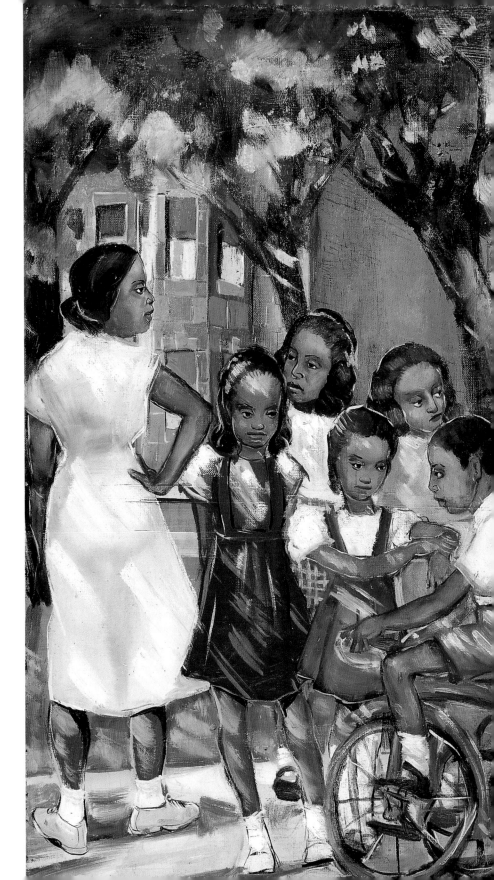

DOUGLASS CROCKWELL

1904–1968

Paper Workers

1934, oil

122.4 x 91.7 cm

Smithsonian
American Art
Museum, Transfer
from the U.S.
Department of
Labor

Paper Workers celebrates labor, progress, and the efficiency and grandeur of the factory. A huge paper milling machine looms over four workers, so rigid that they resemble wood carvings, who smooth the sheets as the paper is wound onto the enormous roll. In its vertical orientation, the mill evokes a great organ being played solemnly in a cathedral of labor. The subdued green, black, and gray palette suggests harmony and cooperation between man and machine. Abstracted, geometric forms symbolize the modernity of the large-scale factory production that catapulted the United States to the status of the world's leading economic power.

Crockwell painted this image during the Great Depression as part of the Public Works of Art Project, a New Deal program. *Paper Workers* originally hung on the walls of the U.S. Department of Labor in Washington, D.C.

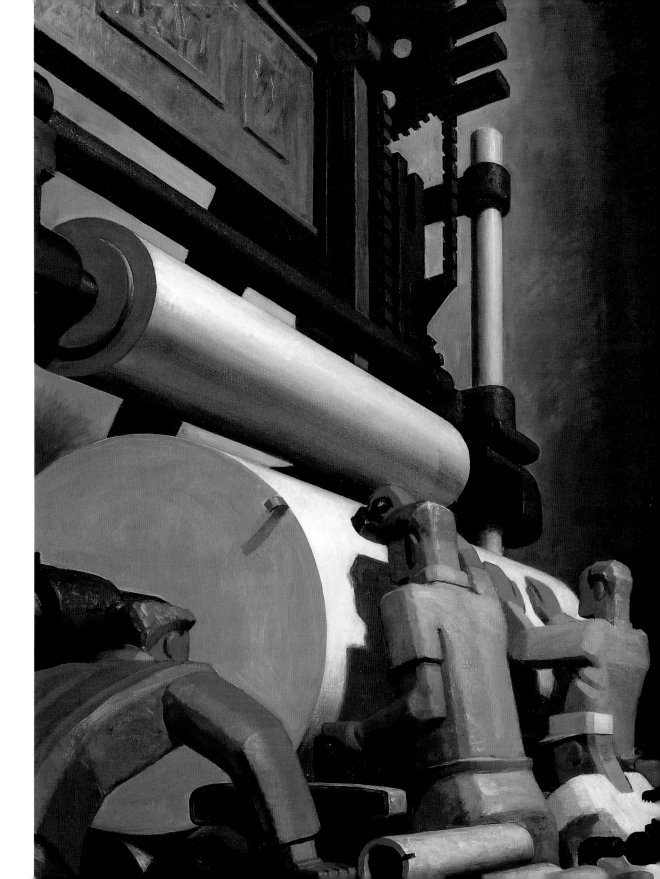

BEAUFORD DELANEY

1909–1979

Can Fire in the Park

1946, oil
61 x 76.2 cm
Smithsonian
American Art
Museum

Rich color, bold pattern, pulsating line, and archetypal forms such as the arrow and circle combine in an image that teeters between realism and abstraction. Here, in an all-too-familiar scene, six homeless men gather around a fire they have set in a trash can; some warm their hands as others brace themselves against the cold. The Depression and World War II have ended, but poverty and deprivation, especially for African Americans, have not.

Tennessee-born Delaney was a friend of the writer James Baldwin and other African American artists who formed a vital expatriate community for the arts in Paris in the 1940s and 1950s. Delaney too departed for France in 1953, seeking the success and acceptance, as a black man and as an artist, that eluded him in America. Destitute, Delaney died in Paris, in 1979, unaware of the career-crowning retrospective of his work that had just opened in New York at the Studio Museum in Harlem.

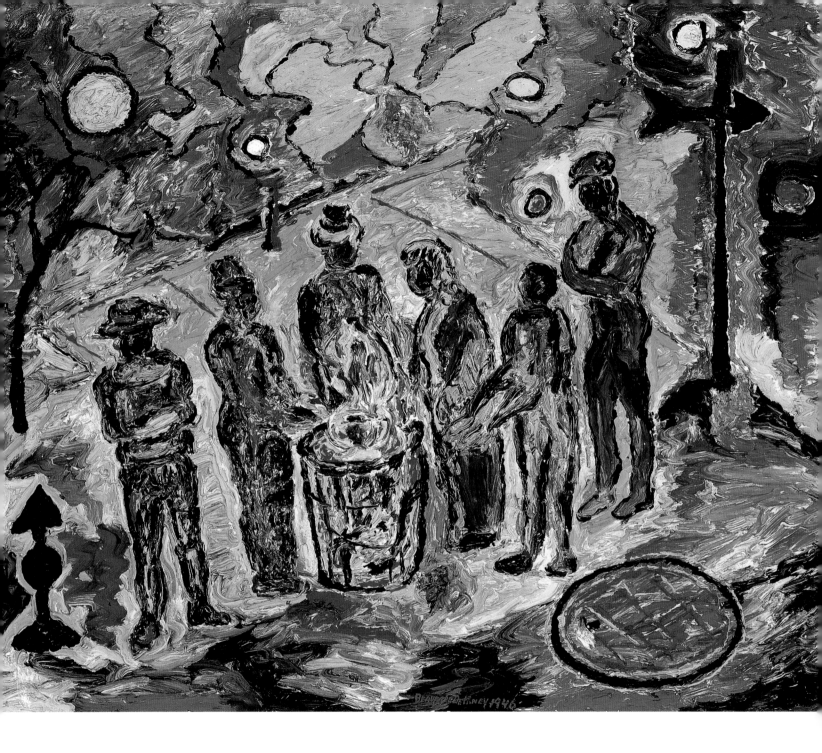

JOSEPH DELANEY

1904–1991

Penn Station at War Time

1943, oil
86.4 x 122.2 cm
Smithsonian
American Art
Museum, Gift of
Joseph Delaney

Few places could be more crowded than New York's Penn Station during wartime. People of all ages, professions, and stations in life mill about in the cavernous structure, since demolished, that was one of the nerve centers of twentieth-century America. The presence of soldiers and military police officers reminds us of the country's engagement with World War II.

The younger brother of Beauford Delaney, Joseph left Knoxville, Tennessee, for New York City. But unlike his brother, Joseph remained in America, studying art in Thomas Hart Benton's class at the Art Students League. Throughout his life, he was committed to opposing racial discrimination, and panoramic crowd scenes like *Penn Station* reveal Delaney's deep concern for the lives of common people.

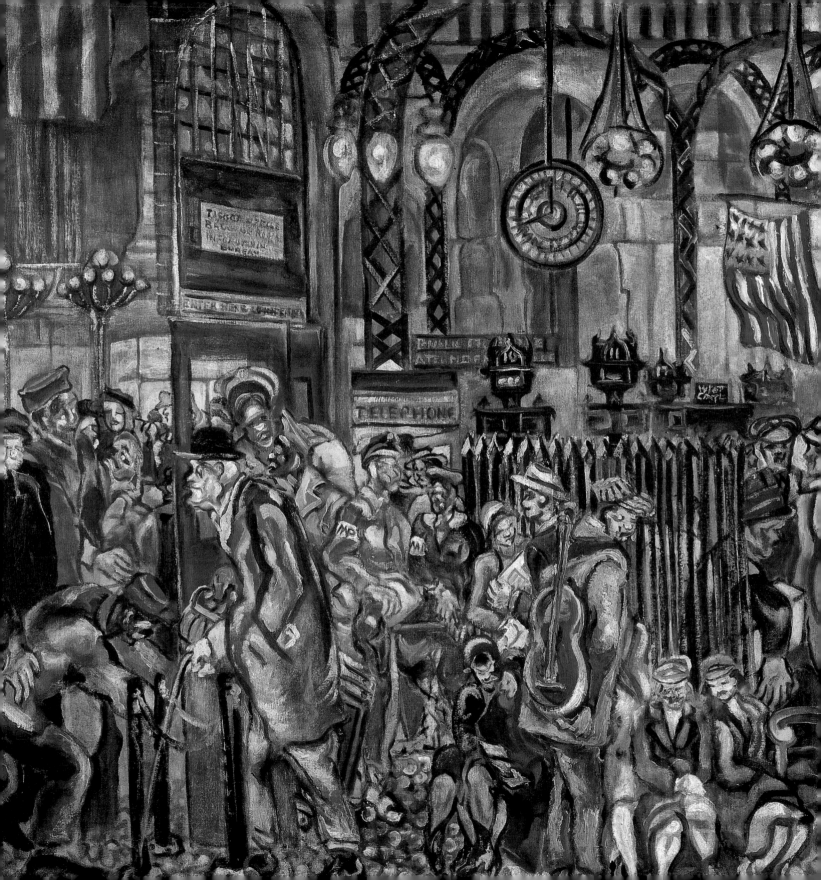

ROSS DICKINSON

1903–1978

Valley Farms

1934, oil
101.4 x 127.3 cm
Smithsonian
American Art
Museum, Transfer
from the U.S.
Department of
Labor

California artist Ross Dickinson frequently painted the dramatic landscape of his home state. This scene of abundance and prosperity, truly a mythic American landscape, was commissioned from Dickinson by the Public Works of Art Project during the Depression, when drought ravaged farms in the Midwest, creating the Dust Bowl. Here, well-kept farms nestle in the valleys surrounded by undulating mountains, and a stream winding across the scene provides ample irrigation for crop cultivation. The soothing greens of the fertile fields complement the yellow and clay reds of the drier hills. Presenting the spectacular results of effective farming in the promised land of California, the painting originally hung in the U.S. Department of Labor in the nation's capital.

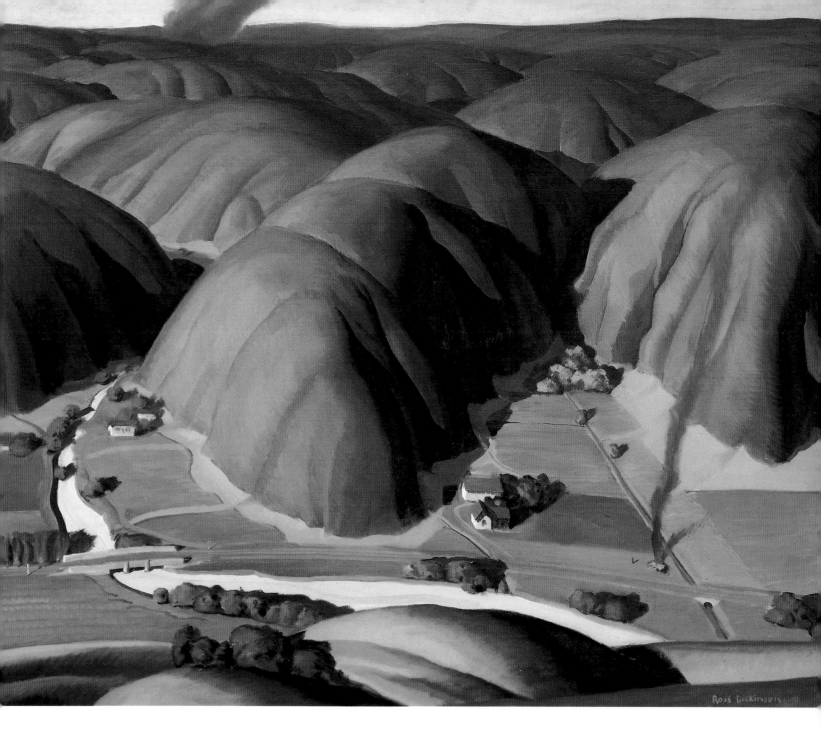

HARVEY DINNERSTEIN

born 1928

Brownstone

1958–60, oil
216 x 152.4 cm
Smithsonian
American Art
Museum, Gift of
Mr. Philip Desind

The entrance to a brownstone apartment building in Brooklyn welcomes the viewer to Dinnerstein's lively scene of urban life in the late 1950s, a vital alternative to the more homogenous suburbs then sprouting on the outskirts of cities. A tapestry-covered cart in the foreground provides a perch for a contented hound as the city dwellers experience the rich texture of New York City. Dinnerstein said that he found models among his own neighbors. An Irish girl ready for a date, an old woman carrying home her shopping, an old man feeding pigeons, Hasidic Jews studying religious texts, a young African American girl carrying her baby sister, and even the artist's own daughter Rachel playing a horn—all pursue their lives under the dignifying pediment of the brownstone.

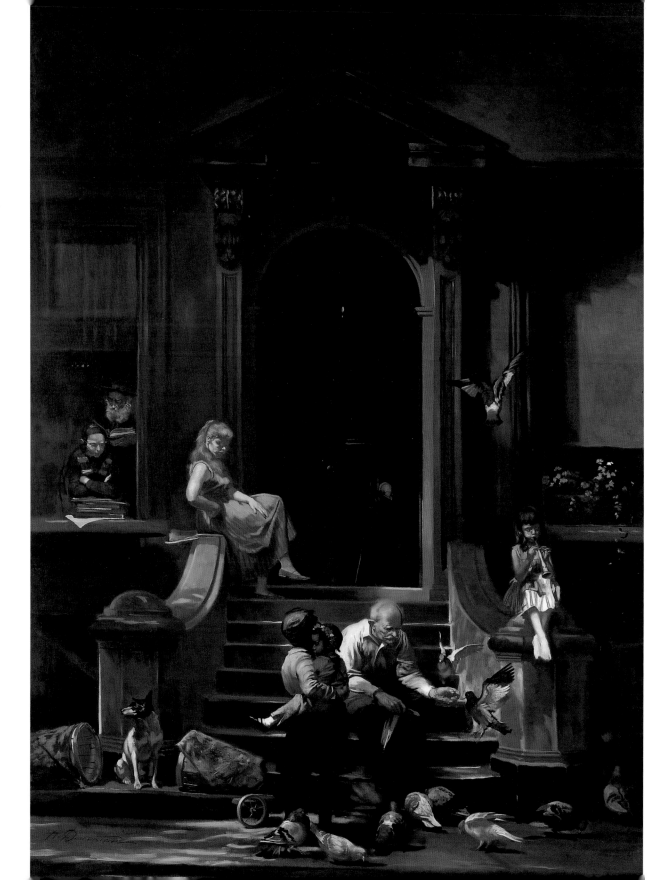

PHILIP EVERGOOD

1901–1973

Woman at the Piano

1955, oil
152.5 x 91.5 cm
Smithsonian
American Art
Museum, Gift of
S. C. Johnson &
Son, Inc.

At first glance, the figure standing beside the piano appears sophisticated and elegant, clothed in her filmy strapless gown; even the vase echoes the form of the singer's ruffled dress. Outside the window, a panorama of New York skyscrapers confirms that we are in a city of great culture. A closer look, however, reveals the painting's satirical bite. The vase holds scrappy ferns, and the tangle of notes on the sheet music and the skewed perspective, rendered with spiky linearity, evoke dissonance rather than harmony. Even the grand piano slides across the floor, threatening to knock over the singer.

In this lighthearted subject, Evergood trained a critical eye on human folly and pretense. A privileged life abroad and his prolonged absence from the United States may have intensified his sensitivity to the mannerisms of the cultural elite. But when he decided to become an artist, Evergood returned to America, where he worked for the WPA Federal Art Project and became one of the best-known realist painters of his time.

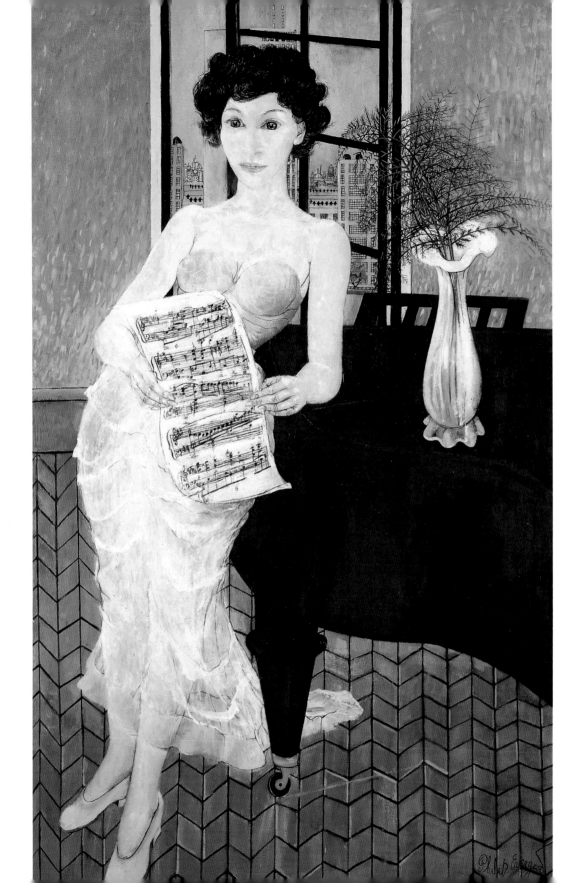

KARL FORTESS

1907–1993

Island Dock Yard

about 1934, oil
81.8 x 122.2 cm
Smithsonian
American Art
Museum, Transfer
from the U.S.
Department of
Labor

Steely grays and smoky reds describe the industrial landscape of Fortess's Depression-era painting *Island Dock Yard*. The wintry view depicts the busy Kingston Point landing of the Hudson River, in New York State, where train lines carry goods to and from shipping ports. Interlocking forms of volumetric train sheds, linear rail tracks, cylindrical grain silos, and triangular-topped water towers are set against patterns formed by leafless tree branches.

The artist knew this region; he was part of New York's Woodstock Art Colony, many of whose participants accepted commissions from the federal government under the auspices of the Public Works of Art Project, and Fortess painted *Island Dock Yard* for that program. It was in the collection of the U.S. Department of Labor before its transfer to the Smithsonian American Art Museum.

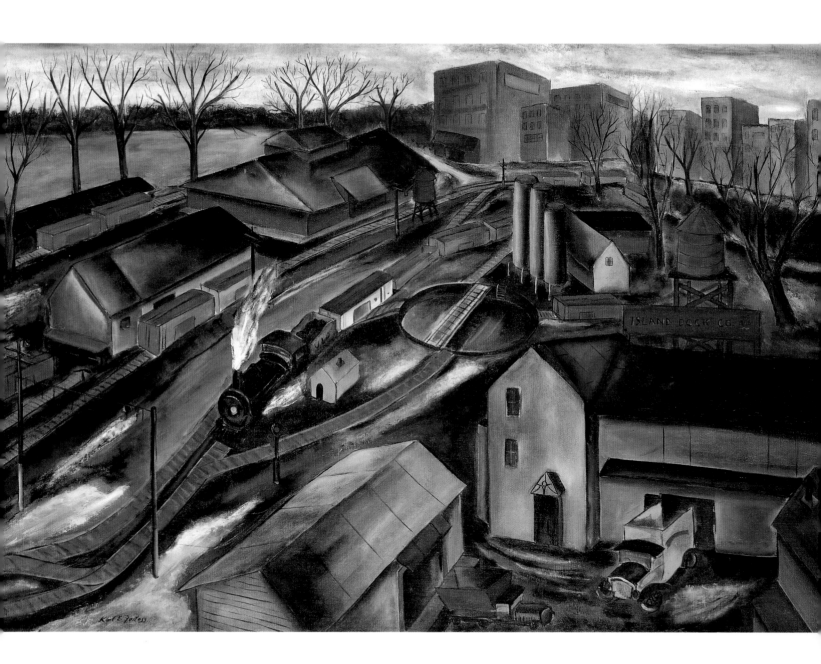

LILY FUREDI

1901–1969

Subway

1934, oil
99.1 x 122.6 cm
Smithsonian
American Art
Museum, Transfer
from the U.S.
Department of the
Interior, National
Park Service

Furedi's penetrating gaze roams the interior of a crowded New York subway car, describing the riders who come together in one of the quintessential activities of urban life. In bright neon pastels, the artist portrays attractive young women and well-dressed ladies and gentlemen. In the foreground, a woman applies her lipstick. A violinist in a tuxedo balances his instrument case between his legs. Scattered throughout the car are workers wearing caps, casual jackets, and open shirts. A web of glances unites these disparate individuals, though most remain wrapped in private thoughts.

It is not known when Hungarian-born Furedi immigrated to the United States, but by 1934 she was employed by the federally sponsored Public Works of Art Project, under whose auspices she painted *Subway.* Interestingly, the artist does not show the worst aspects of the Depression, when unemployment reached record heights. Rather, she represents those fortunate individuals with jobs, emphasizing instead the comforting, ordinary routine of the daily commute.

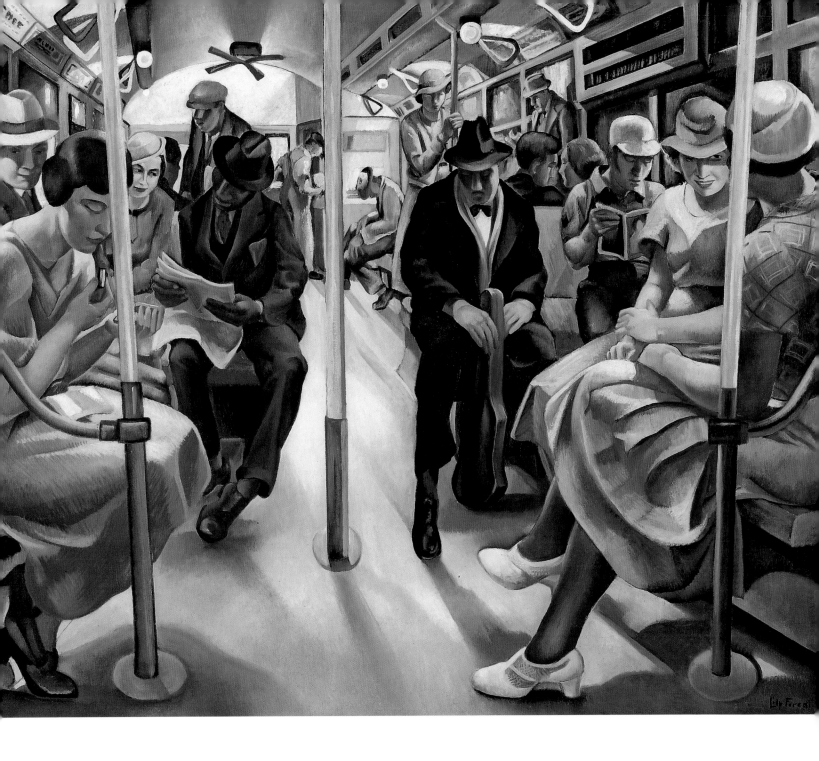

WILLIAM GLACKENS

1870–1938

Beach Umbrellas at Blue Point

about 1915, oil
66.1 x 81.3 cm
Smithsonian
American Art
Museum, Gift of
Mr. and Mrs. Ira
Glackens

Glackens's buoyant view of well-to-do vacationers at the beach at Blue Point, on Long Island's south shore, recalls the work of the French impressionists, especially Renoir. The cheerful white and orange striped umbrellas punctuate the sun-washed sand fronting an elegant resort hotel. Feathery brushwork contributes to the festive quality of the scene as we observe it from out on the water. The joyous color and light describe a world far removed from the realities of World War I, then raging in Europe, or even from New York's alleys and elevated railways, which Glackens illustrated early in his career.

The sense of immediacy that animates this summer spectacle stems from the artist's familiarity with his subject. He and his family summered in nearby Bellport, then becoming an artists' and writers' colony. Their presence signaled the burgeoning pursuit of leisure on the part of America's growing middle class. The 1880s had witnessed a boom in tourism; by 1915, the beaches were already crowded.

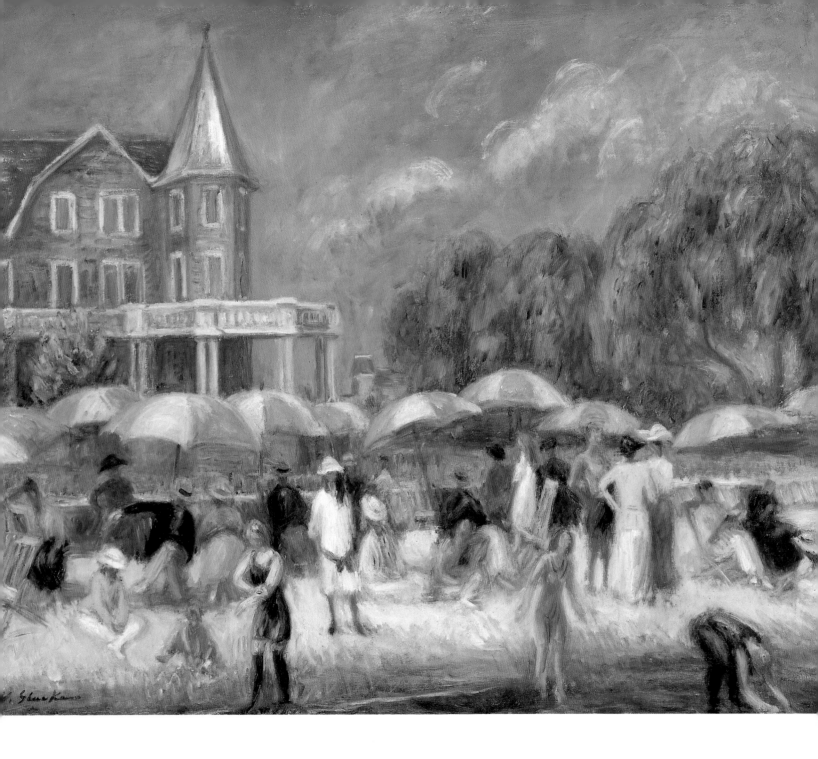

GERTRUDE GOODRICH

born 1914

Scenes of American Life (Beach)

1941–47,
dry pigment in
beeswax emulsion
201.1 x 409.4 cm
Smithsonian
American Art
Museum,
Transfer from the
General Services
Administration

On the hot sand, men, women, and children towel themselves after a post-dip shower, sunbathe, fly kites, toss beach balls, and enjoy the sun. At right, a perspiring police officer in full uniform wipes his forehead as a child tries on his cap. These good-natured, robust, and colorful figures express exuberance, enjoyment, and prosperity. Goodrich's humorous rendition of this crowded beach at-tests to the popularity of swimming as a recreational sport in the twenti-eth century and to the increased access to beaches by public transpor-tation and freeways. One of twenty murals that Goodrich painted for the Health, Education and Welfare building in Washington, D.C., it shows ordinary people having fun on the home front during war years.

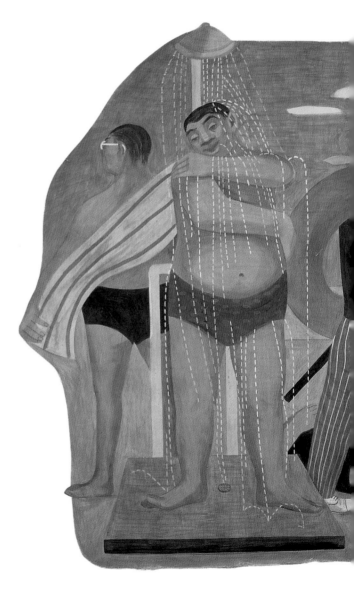

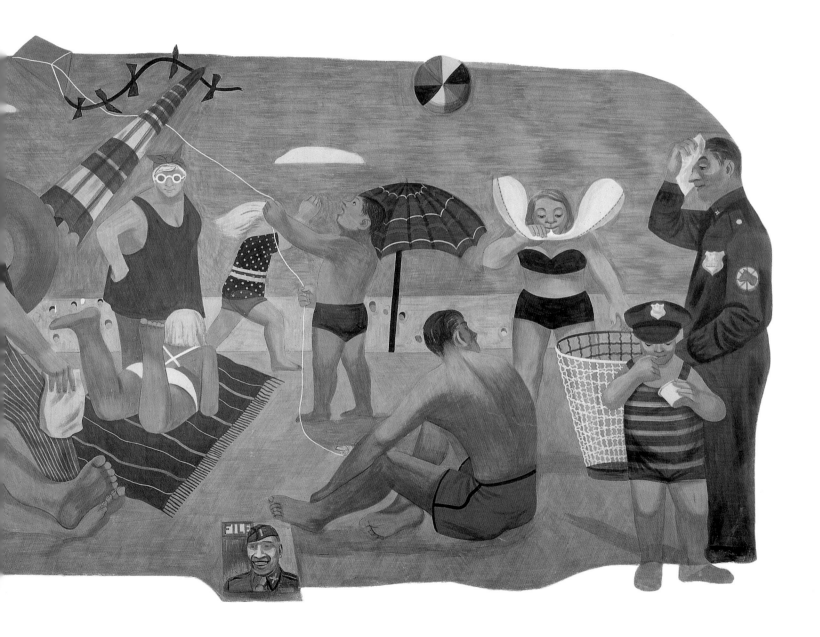

WILLIAM GROPPER

1897–1977

Construction of the Dam

1938, oil
69.3 x 221.7 cm
Smithsonian
American Art
Museum, Transfer
from the U.S.
Department of the
Interior, National
Park Service

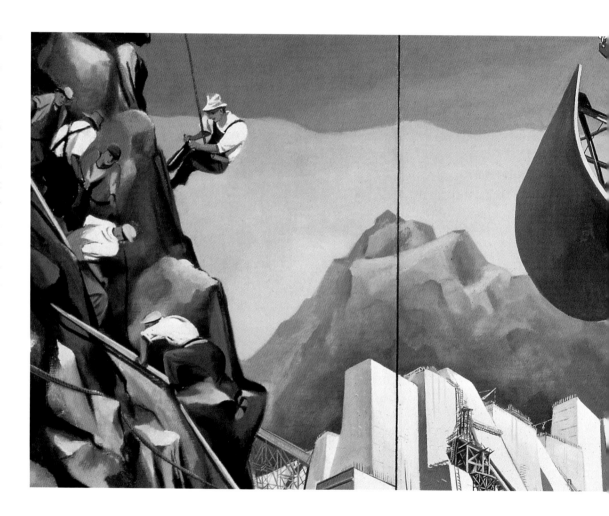

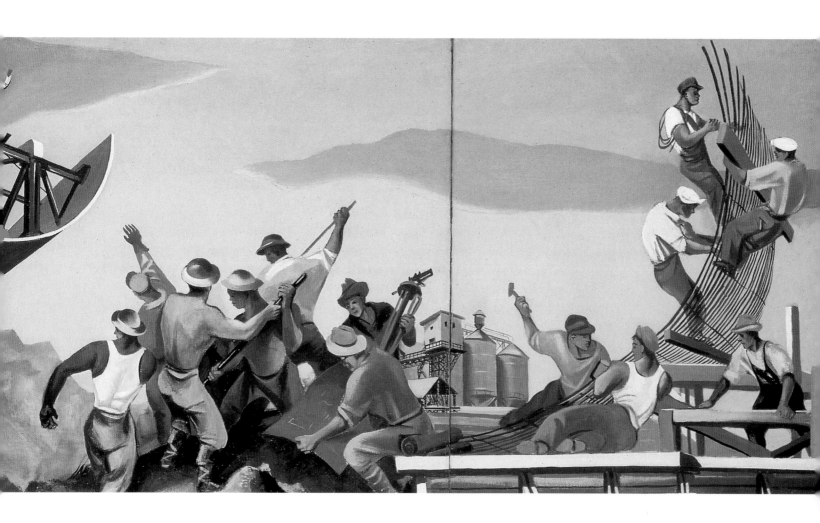

O. LOUIS GUGLIELMI

1906–1956

Relief Blues

about 1938, oil
61.1 x 76.2 cm
Smithsonian
American Art
Museum, Transfer
from Museum of
Modern Art

This scene takes place during the Great Depression, when drastic un-employment led the federal government to provide assistance to those unable to find jobs. Here, a relief worker takes notes on this family's dire situation as they gather in their cramped, sparsely furnished room. The small stove provides the only heat, and the visitor does not take off her coat. Worriedly, the man and woman await her verdict—do they qualify for federal assistance or not?—hopeful yet ashamed to need a government handout. Their teenage daughter scrutinizes herself in a hand mirror, oblivious to the tension of the moment. By the time Guglielmi made this image, the Depression had persisted for almost nine years and the American population was weary. But the jazzy colors and visual puns such as the relief worker wearing a blue hat, and the juxtaposition of her utilitarian shoe and the table leg and foot, add an unexpected touch of humor, even caricature, to an otherwise strained situation.

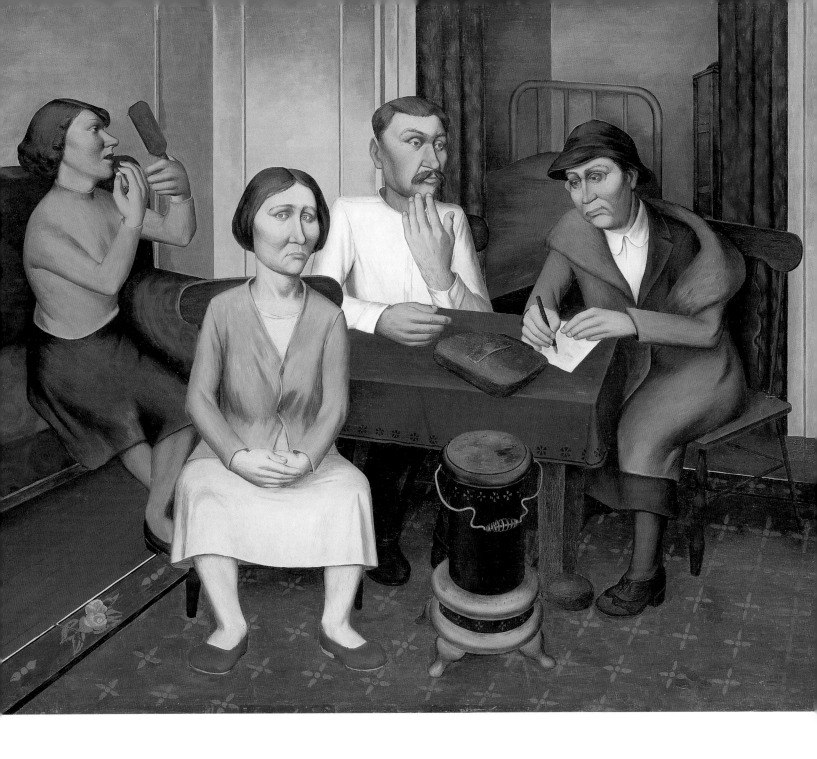

ALEXANDRE HOGUE

1898–1994

Dust Bowl

1933, oil
61 x 82.8 cm
Smithsonian
American Art
Museum, Gift of
International
Business Machines
Corporation

Hogue's dust-choked image portrays a Texas landscape without people or vegetation. A broken, half-submerged barbed-wire fence slashes across this forbidding view, where animals and plows have left their marks in the dust. In the distance sit abandoned farm buildings and a windmill, while the sun struggles to show its face in the blood-red sky above the parched ground.

Oppressive, hostile to life, indeed uninhabitable, this desolate landscape chronicles one of the worst natural disasters the United States has known, the so-called Dust Bowl. The disastrous consequence of bad farming techniques and drought, in the 1930s the country's Great Plains were wracked by recurrent dust storms, called "black blizzards," which suffocated cattle and pastureland. Many farmers, suddenly poverty-stricken, were forced to leave their homes and move farther west in search of fertile land, as recounted in John Steinbeck's poignant novel *The Grapes of Wrath.* It took years to recover from an event that tragically coincided with the Depression and deepened its devastation of the rural population.

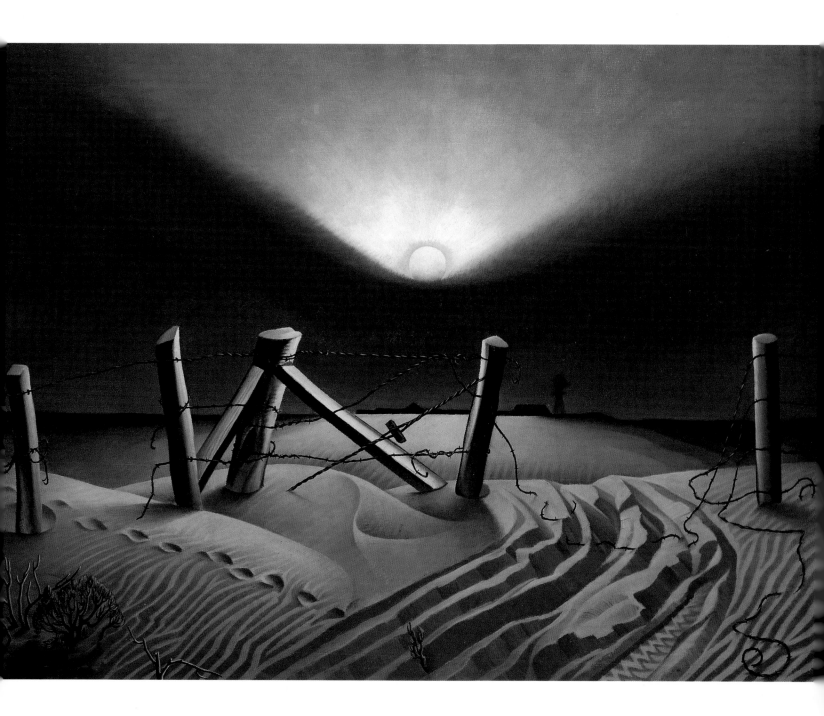

EDWARD HOPPER

1882–1967

Cape Cod Morning

1950, oil
86.7 x 102.3 cm
Smithsonian
American Art
Museum, Gift of
the Sara Roby
Foundation

Urgently leaning forward and grasping the sides of a table with her hands, a woman stands riveted by something unseen beyond the picture space. The tall dark shutters of the bay window seem to trap her within the white clapboard house, which occupies exactly one half of the canvas. Nature fills the right half with horizontal bands of intense sunlight, blue sky, and trees and grasses, as open and inviting as the house is confining. Famous for his images of lonely and alienated people, Hopper creates a morbid stillness and desperation in this stark, ambiguous image. The picture deliberately does not tell a specific story, leaving the viewer with an uncomfortable lack of resolution. Using the setting of Cape Cod, Massachusetts, which he knew well, Hopper infuses this simple scene with a mood of indelible anxiety.

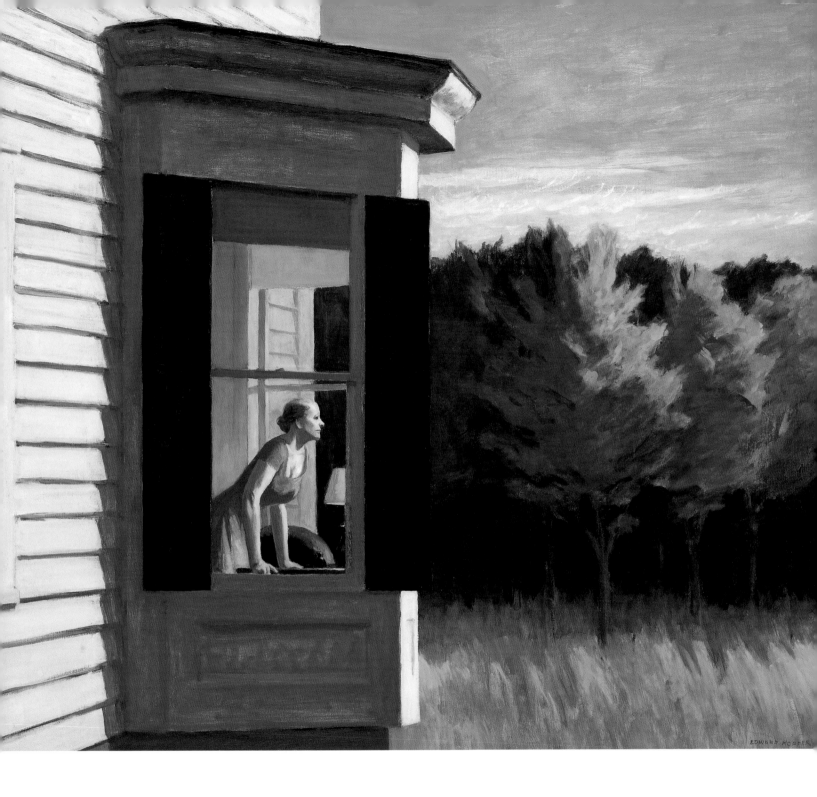

EDWARD HOPPER

1882–1967

People in the Sun

1960, oil

102.6 x 153.4 cm

Smithsonian

American Art

Museum, Gift of

S. C. Johnson &

Son, Inc.

Five people sit in deck chairs on a patio at an undefined location. The late afternoon sun casts their long blue shadows on the concrete as they face a field of ocher grasses and, in the distance, a range of mountains. Although Hopper suggests hot weather with the blue sky and the strong illumination, the figures are warmly clothed in oddly formal garb. Hopper characterizes each person by clothing, hairstyle, a hat, a moustache, yet with the exception of the more casual man at far left, they remain silent and rigid, not acknowledging the others' presence. The artist heightens the alienated mood of the individuals and the desolation of the landscape by the stark geometry of his composition. Even the lively and decorative patterns of the crisscrossed chair legs cannot diminish the effect of frozen isolation that sends a chill through this and so many other of Hopper's visions of twentieth-century American life.

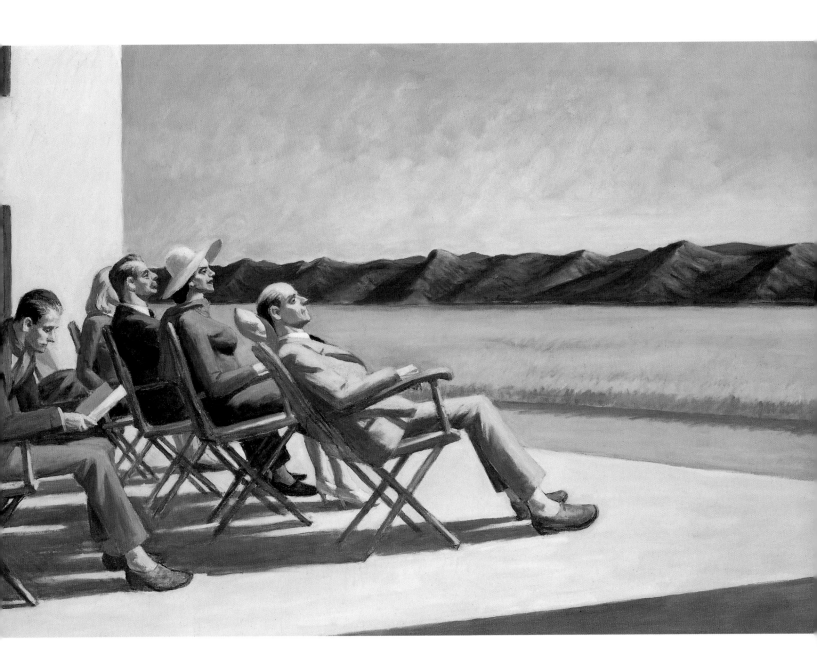

WILLIAM H. JOHNSON

1901–1970

Early Morning Work

about 1940, oil
97.8 x 115.9 cm
Smithsonian
American Art
Museum, Gift of
the Harmon
Foundation

South Carolina–born Johnson returned to the United States in 1938 after a long stay in Europe, determined to paint "the story of the Negro as he has existed." In *Early Morning Work,* a father, mother, and son prepare for another day on the farm. The father holds a handmade plow, which he prepares to yoke to a mule. The figures' stiff stances recall African tribal sculpture, a deliberate reference by the artist as part of his "painting of my people."

Although Johnson was trained at the National Academy of Design and worked for many years in an expressionist modern style, his late subjects about black life in the South show a simplified, almost "folk" or "primitive" style. A preference for bold patterns and stripes, strong shapes and pure colors, gives the work exceptional power and directness. All shapes and lines seem to converge on the tightly knit family, and their emotional bond is emphasized through their clasped hands.

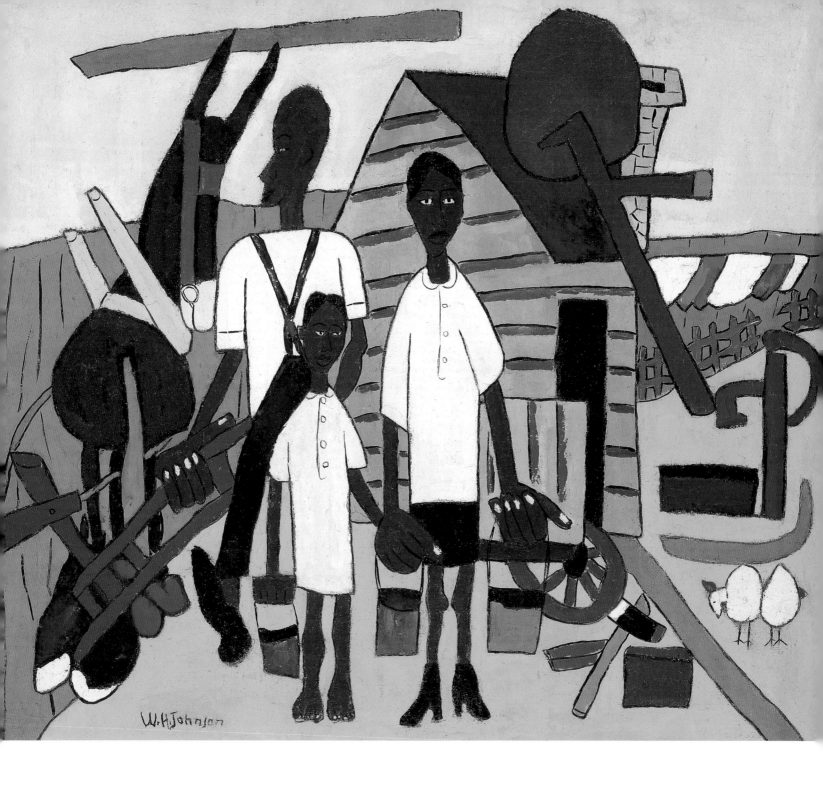

MARGARET BRASSLER KANE

born 1909

Harlem Dancers

1937, marble
75.9 x 36.8 x
35.6 cm
Smithsonian
American Art
Museum,
Gift of the artist

When by chance Kane came across a fine block of Tennessee marble in a stone yard near her Manhattan studio, she instinctively realized that it would suit the subject of two dancing figures that had been on her mind since 1935. She did not use models. Rather, as she chipped away at the marble, the dancers emerged from the stone as if of their own accord. The bodies of the man and woman, hewn from the same block, blend into each other in the slow intensity of the music. She nestles her head under his neck as she clasps him close to her, locking them into an erotic embrace. Kane enlivens the sculpture's surface with a design for the woman's dress that emphasizes her feminine curves. It derived, recounted the sculptor, from the pattern on a peanut shell lying in a nearby bowl in her studio. As Kane observed, she "welcomed the idea of using a black couple because of [her] admiration for minority groups who have struggled for equal opportunity."

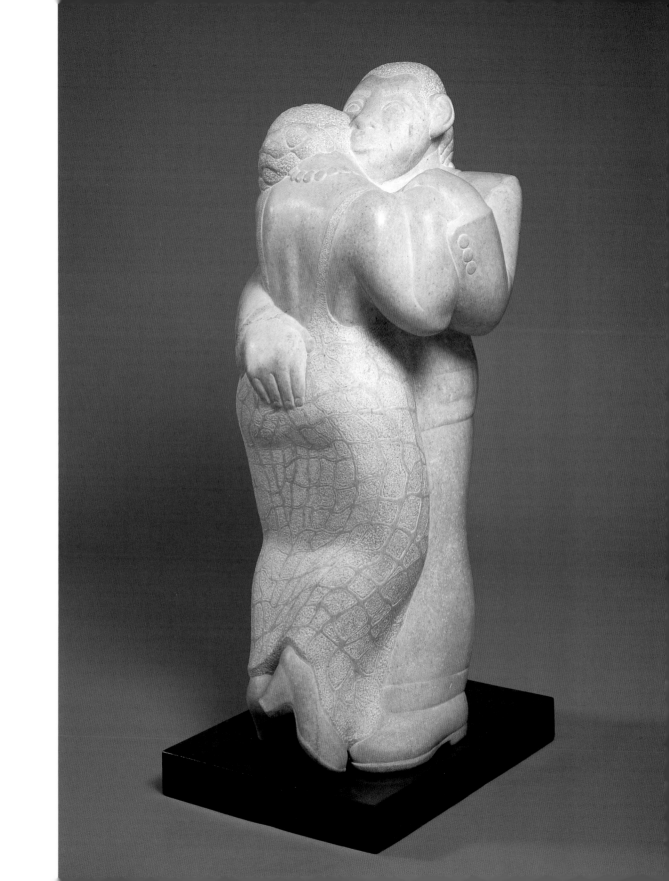

MORRIS KANTOR

1896–1974

Baseball at Night

1934, oil
94 x 120 cm
Smithsonian
American Art
Museum, Gift of
Mrs. Morris
Kantor

Is there a more American sport than baseball? Kantor, born in Russia, embraced the subject as the essence of idealized American life. This is not big-league baseball, but a small-town night game, yet the lights, team uniforms, professional umpire, and radio broadcasting station show how seriously this town takes the national pastime. The American flag cements the nationalistic flavor of the sport. The work's animated optimism and affirmation of enduring values acquire even greater significance since it was painted during the Depression.

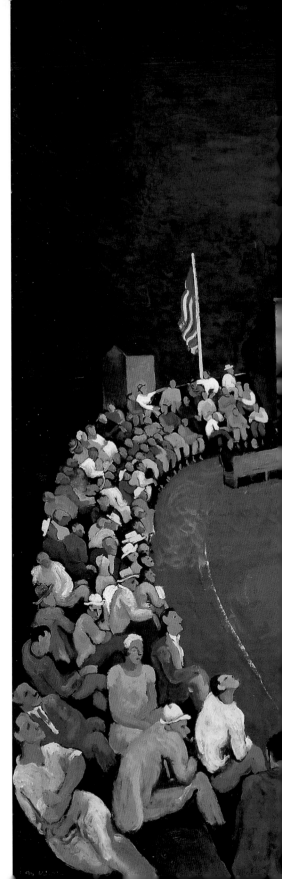

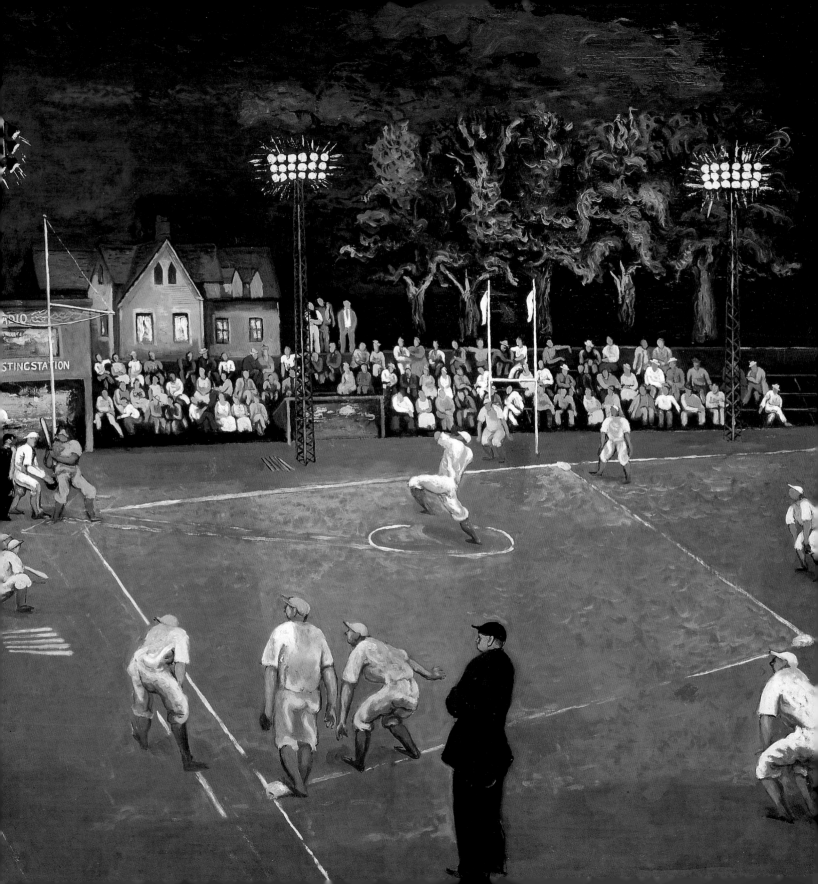

ROCKWELL KENT

1882–1971

Snow Fields (Winter in the Berkshires)

1909, oil
96.5 x 111.7 cm
Smithsonian
American Art
Museum, Bequest
of Henry Ward
Ranger through the
National Academy
of Design

"The beauty of those Northern winter days is more remote and passionless, more nearly absolute, than any other beauty that I know," observed Rockwell Kent in 1935. Following in the tradition of such great nineteenth-century American artists as Winslow Homer, Kent "tuned" the whiteness of the snow to "sun-illumined blue," as he divided this vibrant view of the Berkshire mountains into three horizontal zones of light green sky, blue hills and trees, and a sunny, snowy plain. Two mothers with children delight in their winter stroll while two dogs frolic in the invigorating air. The haloed sun casts strong blue shadows on the deep snow, created with a few masterfully smudged brush strokes. Even the wispy plant at lower right, pushing its way up through the snow, has a shadow that echoes the artist's signature next to it. *Snow Fields* captures the grandeur of the great empty spaces of the American land.

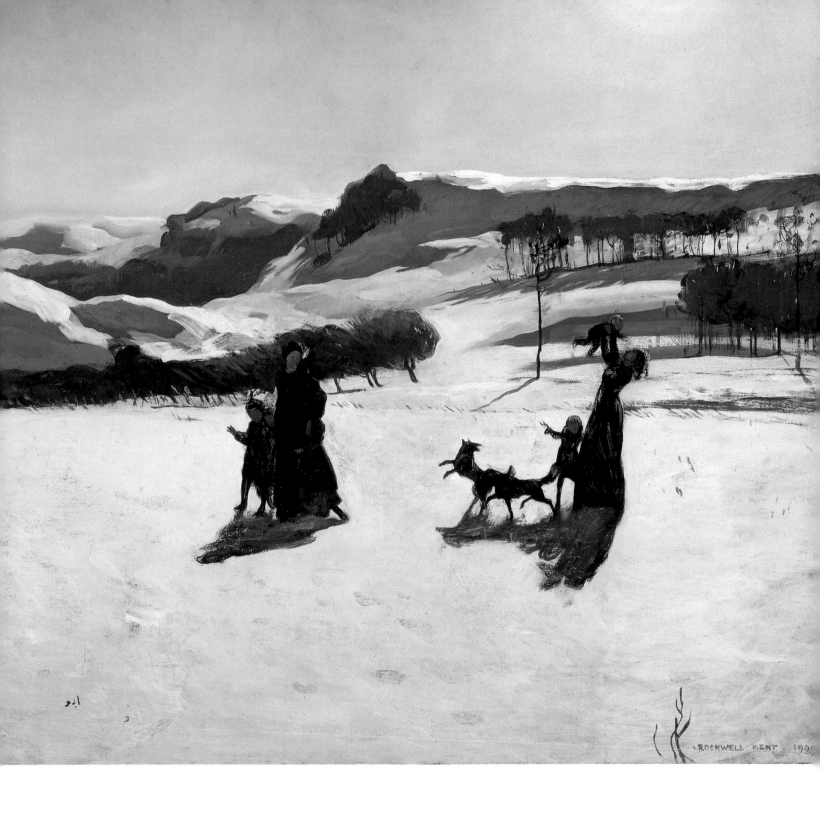

FRANK C. KIRK

1889–1963

Homeward

1933, oil
122.4 x 97.2 cm
Smithsonian
American Art
Museum,
Gift of Mrs. Frank
Cohen Kirk

Two coal-blackened miners return home, heroically silhouetted against the evening sky. With a pickax over his shoulder and an acetylene lamp still mounted on his cap, the man on the right looks at the viewer, exhausted but undefeated. His companion gazes straight ahead as he strides forward purposefully. This epic canvas embodies the artist's beliefs: "What should be my credo other than my work that reflects life around me—episodes of daily struggle and human drama? . . . In my painting gamut I give preference to the toiler and his station in life, to the miner with his coal-blackened face, the hunch-backed little street he lives on and never sees in daylight; landscape and still life of social meaning are also my themes."

Born in Russia, Kirk immigrated to the United States in 1908, an exile from the persecution of Jews by the czarist government. He later returned to the new Soviet Union a number of times and visited Europe as well. Interestingly, works such as *Homeward* resemble the socialist realism of Stalin's Russia as much as America's celebration of laborers during the Depression; glorification of the worker seems to look similar in all countries.

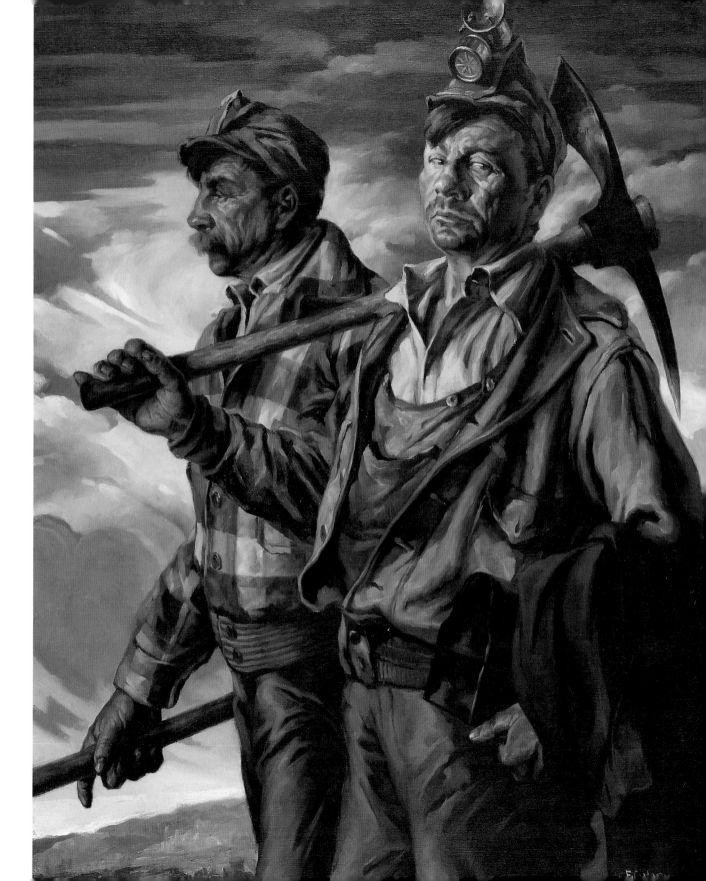

YASUO KUNIYOSHI

1889–1953

Strong Woman and Child

1925, oil

145.4 x 114 cm

Smithsonian

American Art

Museum, Gift of

the Sara Roby

Foundation

Vibrant reds dominate this image of a circus strong woman clasping the hand of a young boy, a performer in training. They pose for the artist on a wooden platform decorated with French flags. In the background, a grand white structure evokes a French château. The large, almond-shaped eyes of the figures gaze away from the viewer; their contemplative mood belies their active profession.

Kuniyoshi, who emigrated from Japan in 1906, received classical training in painting in New York City, supporting himself as a photographer in the 1920s. A painter of social realist subjects throughout much of his career, he turned to the subject of children in the early 1920s. In works such as *Strong Woman and Child,* Kuniyoshi creates an evocative blend of the early American folk art he came to love with a modernist abstraction reminiscent of contemporary Parisian art.

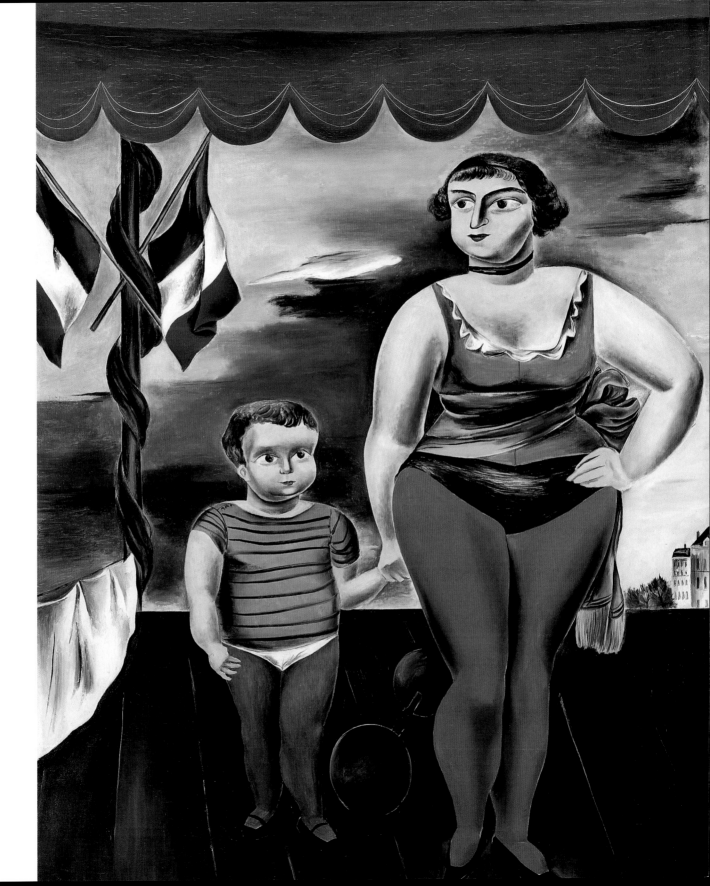

JACOB LAWRENCE

1917–2000

The Library

1960, tempera
60.9 x 75.8 cm
Smithsonian
American Art
Museum, Gift of
S. C. Johnson &
Son, Inc.

Deep in concentration, hunched over books, thirteen figures populate the reading room of a public library. Lying open on the wooden tables, perused intently by the readers, are art books filled with pictures of African tribal sculptures. A fourteenth person clasps a pile of books to her chest like precious objects as she strides eagerly across the room.

Lawrence created a deceptively simple design of the bold horizontal and vertical forms of the three reading tables with their prominent wood grain. Strong accents of blue, red, and green syncopate the rhythms across the picture surface. The tight composition reflects the sense of quiet order yet lively intellectualism that informs this image. Lawrence himself had relied on the public library in Harlem in New York City for the study of his African American heritage, which formed the basis of his art during more than six decades.

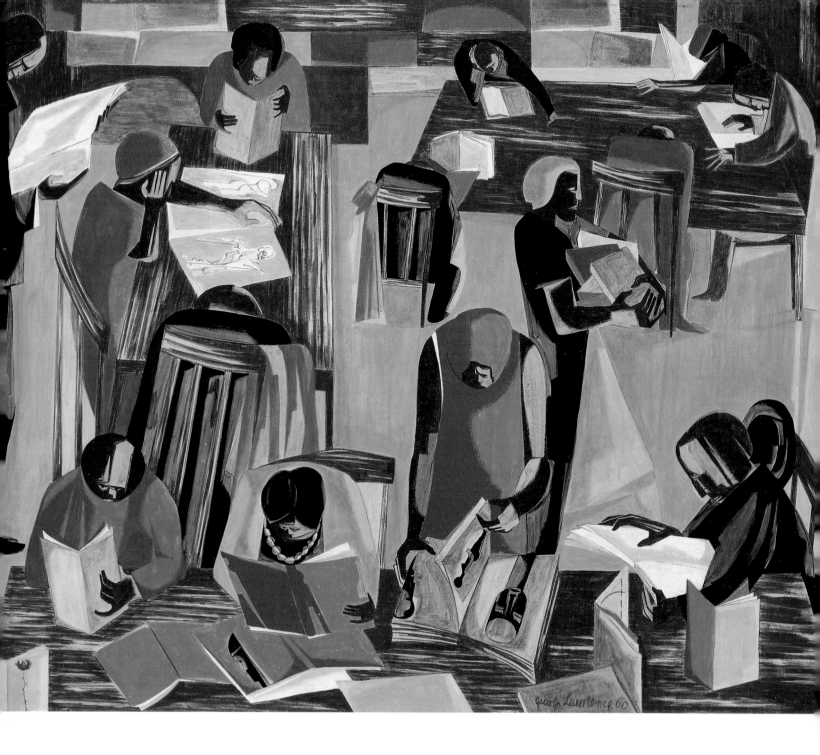

Double Portrait of the Artist in Time

1935, oil

121.3 x 101.6 cm

Smithsonian

American Art

Museum

Lundeberg's hypnotic self-portrait in time is a meditation on the mystery of aging. Its symbolism is unmistakable. In a stark interior, a girl in a pristine white dress sits at a tiny table, holding a budding flower, a symbol of youth. On the parchment-like table cover, where one can make out the words "Ages of Man," sits a clock set at a quarter past two, the age of the child. A tall violet shadow behind her rises up to the painting within the painting, where the mature artist, in profile view, contemplates the flower, now in full bloom. A spherical box, decorated with a map of the globe, lies open, revealing only emptiness—an unknown future of potentiality.

Lundeberg and other California artists rejected the representation of the American scene pursued by many of their contemporaries. Instead, they invented a movement they termed postsurrealism, which explored deep psychological truths. A visual poem on a metaphysical theme, this portrait may well be Lundeberg's masterpiece.

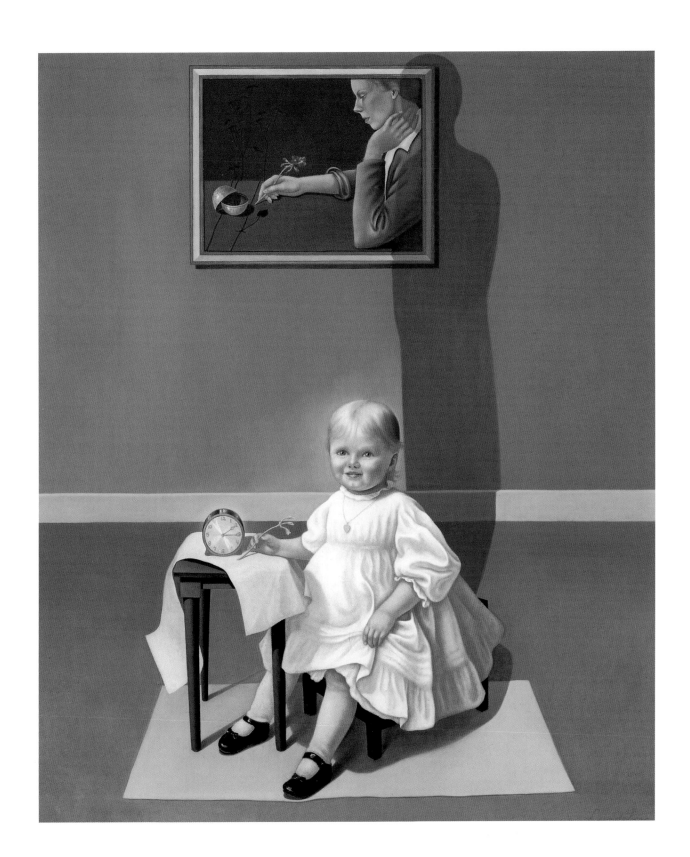

PAUL MANSHIP

1885–1966

Playfulness

1912, cast 1914;
bronze on
marble base
34 x 32.1 x 17.8 cm
Smithsonian
American Art
Museum,
Gift of the artist

A mother bounces her child on her knee in a game not limited by time or culture. Yet the decorative stylization of hair and drapery betrays the sculptor's inspiration from the earliest Archaic Greek styles. Manship rejected the realism of traditional sculpture in his age in favor of the so-called primitive phase of Greek art. A sojourn in Rome from 1909 to 1912 fueled this interest. The artist designed *Playfulness* at the end of his stay; it possesses the freshness of direct inspiration. Manship's sculpture in general was known for its impeccable craftsmanship and finish, contributing to his reputation as one of America's most famous artists of the early twentieth century. Delicacy of lines and folds, high polish, graceful smooth silhouette, and the restraint of the marble base distinguish a work of true expressive elegance.

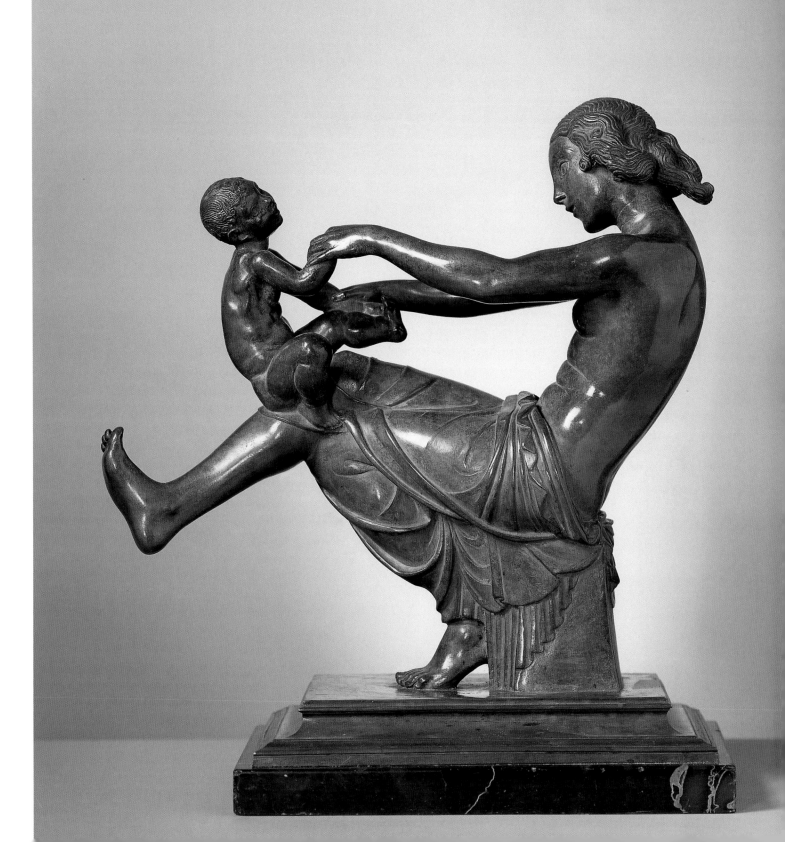

REGINALD MARSH

1898–1954

George Tilyou's Steeplechase

1932, oil and
egg tempera
76.5 x 101.8 cm
Smithsonian
American Art
Museum, Gift of
the Sara Roby
Foundation

Steeplechase Park was one of three amusement parks at Coney Island in Brooklyn, New York. Developed by George Tilyou in 1897, the Steeplechase ride consisted of mechanical horses that raced around the grounds on iron rails, which in certain places were some thirty-five feet high. Marsh's work, though unmistakably conveying America's love of raucous entertainments, also updates classical subjects from antiquity, such as the Battle of the Centaurs, in which half-human, half-equine steeds abduct beautiful maidens. Here an ordinary sailor on holiday takes his girl on a honky-tonk amusement park ride, the horses no more than clever mechanical toys.

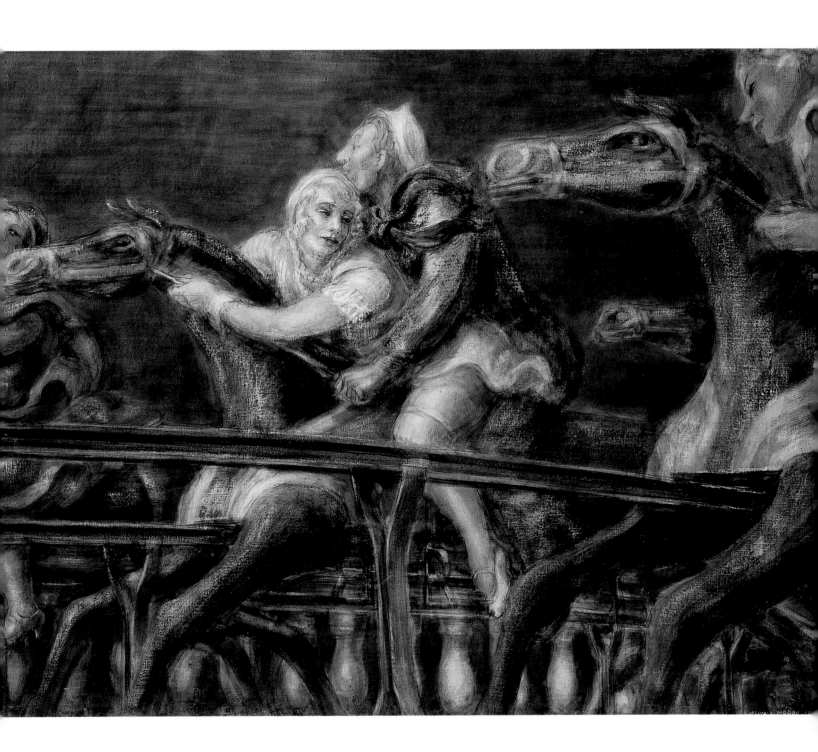

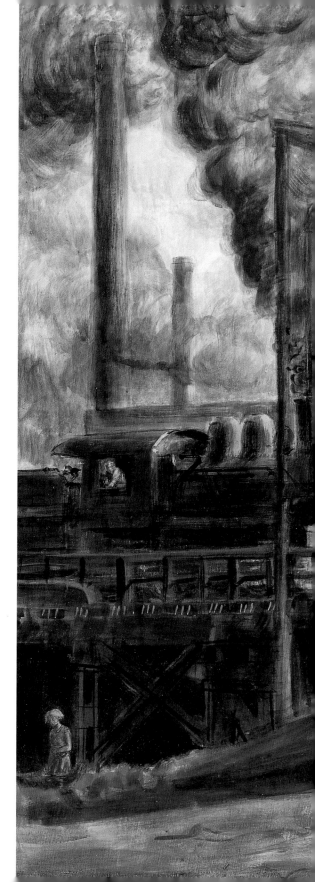

REGINALD MARSH

1898–1954

Locomotives, Jersey City

1934, oil
91.9 x 122.5 cm
Smithsonian
American Art
Museum, Bequest
of Felicia Meyer
Marsh

A symphony of blacks, the locomotives claim their place as protagonists in an industrial drama. One proceeds under an iron structure as if through a grand triumphal arch, an emblem of power that provided endless inspiration to Americans in the grip of economic depression. Touches of red signal the three men present, two walking and one seen through the window of the train, but they are dwarfed by the smoke and steam that twist like cyclones from the locomotives' funnels.

This picture represents one of a series, begun in the 1930s, in which Marsh concentrated on different facets of American transportation. He developed the sketchy style, shown here, partly from his early experience as a freelance contributor to newspapers and magazines, including *Vanity Fair* and *Harper's Bazaar.* Even in his formal paintings, the artist never lost the illustrative flair that vividly renders the first half of the twentieth century in America.

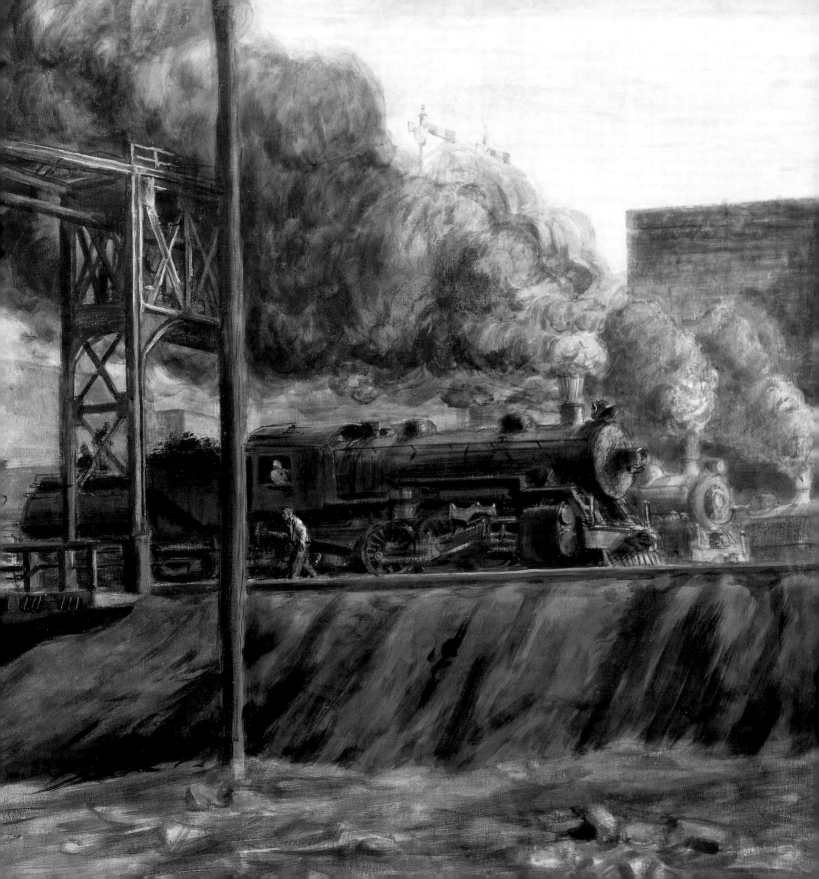

ROGER MEDEARIS

born 1920

Godly Susan

1941, egg tempera
70.1 x 60 cm
Smithsonian
American Art
Museum,
Gift of Roger
and Elizabeth
Medearis

Missouri-born Medearis painted this portrait of his grandmother when he was just twenty-one and was concluding studies with the regionalist painter Thomas Hart Benton in Kansas City. Descendant of two Baptist preachers and mother of three more, she was known as "Godly Susan." Medearis would wheel his grandmother, disabled by stroke, up a ramp to his studio, where he made detailed sketches while she sat, often falling asleep. In her left hand she held a lemon because she loved the tangy taste of the fruit. A committed realist, the artist then made a clay model of the rest of the scene as he imagined it and went into the countryside to sketch the church, stones, trees, and broken pieces of wood. Painted in egg tempera, the picture is rich with the delicate detail and luminescence characteristic of this medium. Susan's majestic figure rests amid her beloved nature, stalwart as the grand tree behind her, salt of the American earth.

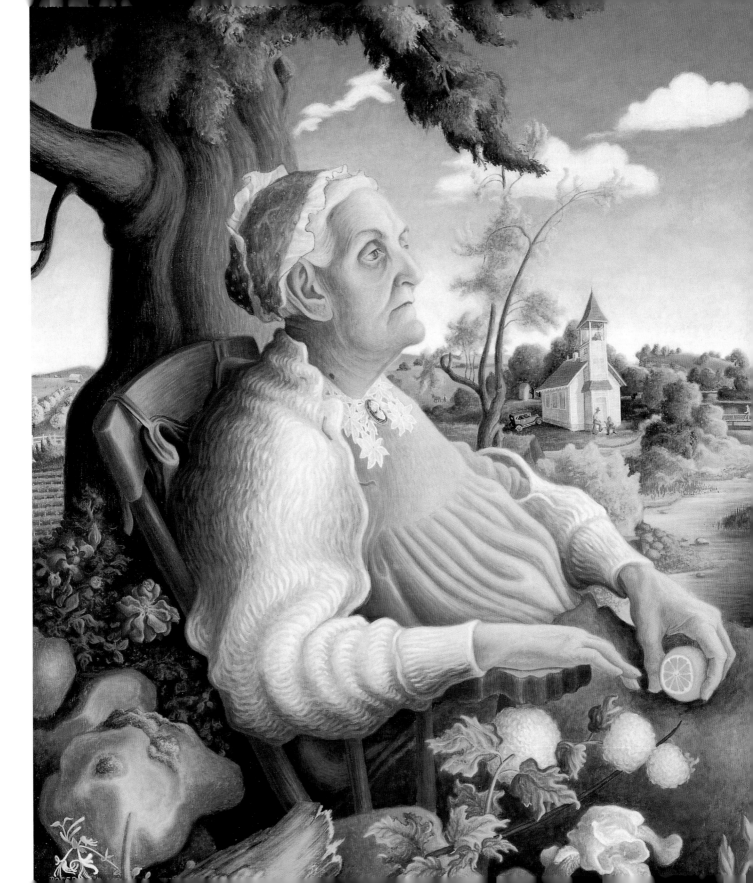

KENJIRO NOMURA

1896–1956

The Farm

1934, oil

97.2 x 117.1 cm

Smithsonian
American Art
Museum, Transfer
from the U.S.
Department of
Labor

Nomura's painting is a portrait of the perfect farm. It depicts a rural landscape near Seattle, where Nomura and his family settled after emigrating from Japan when the painter was a young boy. Red buildings sit at angles to each other, grouped around a gray grain silo. A path bordered by a fence leads us diagonally past the farm on our passage through the countryside. Leafy green trees and fluffy clouds lend an organic, more relaxed note to an otherwise intensely geometric, simplified composition. In the curious absence of figures or animals, the buildings themselves become the protagonists of this quietly noble settlement.

The artist painted *The Farm* under the auspices of the Public Works of Art Project during the Depression. Yet ironically and tragically, after being hired in 1933 by the PWAP to celebrate the American scene, Nomura, along with many other Japanese Americans, was forced into an internment camp during World War II. This injustice brought his career to an end until 1947, when he began exhibiting again.

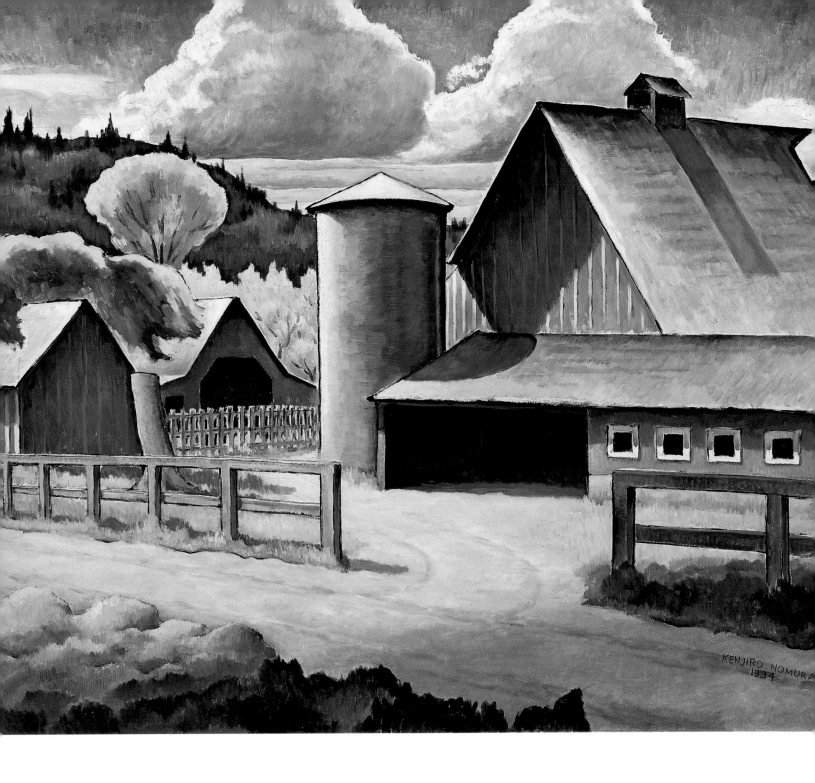

HORACE PIPPIN

1888–1946

Old Black Joe

1943, oil
61 x 76.1 cm
Smithsonian
American Art
Museum,
Museum purchase
through the
Luisita L. and
Franz H.
Denghausen
Endowment

Seated on a split-log bench in a field of daisies, Old Black Joe looks sadly out at the viewer. Too old now to labor in the cotton fields that stretch beyond a great plantation house, he lives out his life tending to a child, who is tethered to him with a leash and whose mother keeps a sharp eye from the house. Pippin found inspiration for his canvas in Stephen Foster's 1860 song of the same title. It tells the story of the elderly slave and became popularized by Al Jolson's performance in the 1939 film *Swanee River,* a fictionalized musical biography of Foster.

The painting was commissioned by a manufacturer of radios for reproduction as a full-page *Life* magazine ad, where it helped sell the power of music as a soothing antidote to World War II. In its simple lines and bold colors, Pippin's work, however, avoided the sentimentality overlaid on it by the radio company and by Foster's minstrel ballad. The artist endows his figure with dignity and elevates the scene to a meditation on the moral vacuum of slavery.

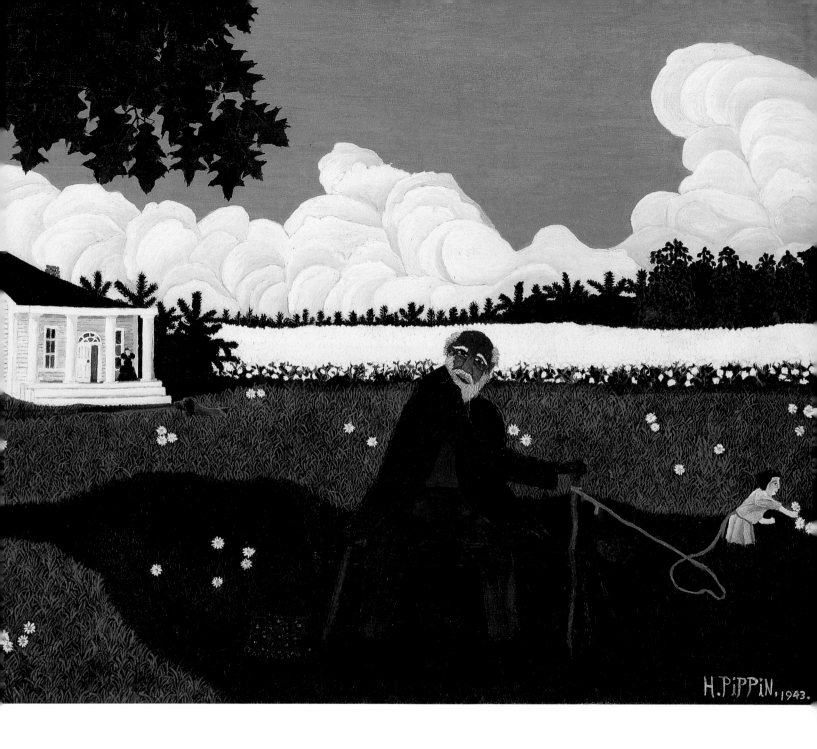

H.PiPPiN, 1943.

EARLE RICHARDSON

1912–1935

Employment of Negroes in Agriculture

1934, oil

121.8 x 81.6 cm

Smithsonian
American Art
Museum, Transfer
from the U.S.
Department of
Labor

Richardson painted this canvas during the Depression as a commission from the Federal Art Project of the New Deal. With deep sensitivity to bold pattern and color as well as to human dignity, the artist portrays four Southern black sharecroppers as they haul bales of cotton from the lush fields behind them. We do not know where the work was made; it has been suggested that the scene may represent the Mississippi Delta region, or perhaps the fertile cotton fields between Vicksburg and Natchez.

Richardson was born in New York and studied at the National Academy of Design. Only twenty-two when he painted this, he committed suicide one year later. When he died, he was at work on a federally sponsored mural depicting the history of the Negro. In this image, he affirmed his view of rural blacks as young, powerful, and undefeated, a people whose time would come.

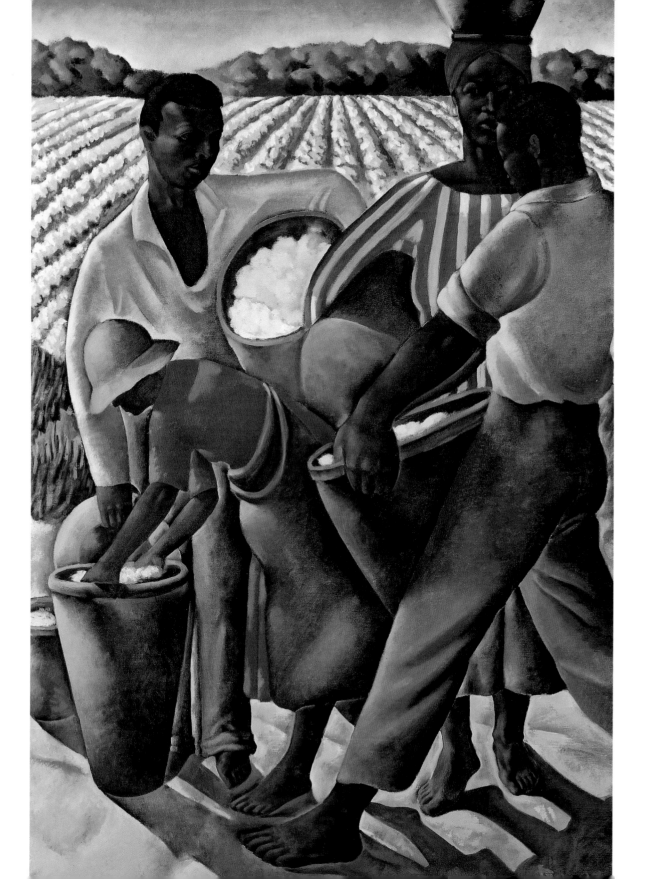

HUGO ROBUS

1885–1964

One and Another

1934, bronze on
wood base
73 x 111.5 x 59.4 cm
Smithsonian
American Art
Museum, Gift of
the Sara Roby
Foundation

Robus's sculpture captures the age-old theme of mother and child. The elegant design and exquisite finish of the work recall his training as a jewelry maker before he turned to painting and then to sculpture. But deeper meanings emerge through the artist's sensitive interweaving of the figures. The silhouetted pattern that they trace evokes the double ovals of the infinity symbol, alluding to the bond, the mutual interdependency, between mother and child. Each figure is complete, yet interlocked. In this way, Robus acknowledges a basic human truth: our essential aloneness and our need for another. We are both *one* and *another.*

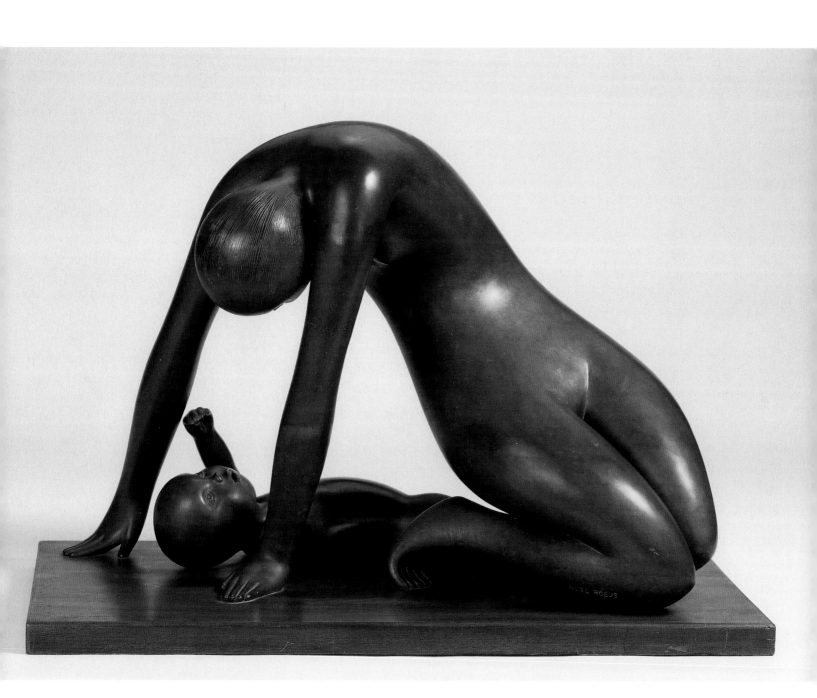

JOSEPH RUGOLO

1911–1983

Mural of Sports

about 1937–38, oil
183.5 x 244.2 cm
Smithsonian
American Art
Museum, Transfer
from the Newark
Museum

Rugolo's jaunty *Mural of Sports* captures the skill and energy of important athletes of his day. A baseball catcher and batter, two hockey players, a runner, and a tennis player perform before a goalie cage and a sports stadium.

The national flag waving above celebrates the connection between sports and patriotism. Rugolo identified the runner as Olympian Jesse Owens, who astonished the world with four gold medals at the 1936 Berlin games; the tennis star is Helen Wills Moody Roark, who took gold medals at the 1924 Paris Olympics in women's singles and doubles.

The mural division of the Works Progress Administration, a federally funded art program, commissioned this painting. It hung in the gymnasium at Roosevelt High School in New York City as an inspiration to students before finally being transferred to the collection of the Smithsonian American Art Museum.

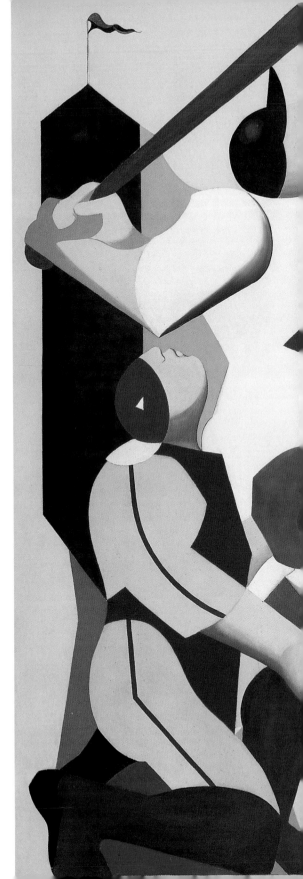

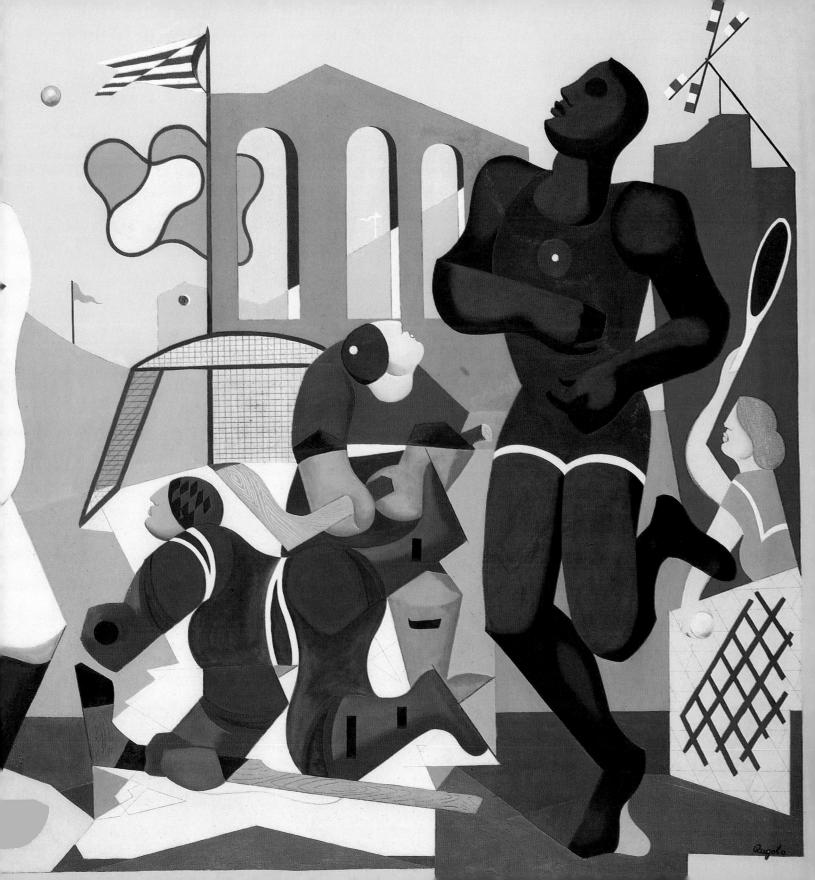

HONORÉ SHARRER

born 1920

Tribute to the American Working People

1951, oil
98.5 x 196.2 cm
Smithsonian
American Art
Museum, Gift of
the Sara Roby
Foundation

In this complex multipanel painting, Sharrer invites us to "drop in" on our American neighbors. Surrounding the central panel of a factory and worker—the economic hub of the community—we see a county fair, small-town parlor, school classroom, and barnyard scene, all part of the fabric of American life. These are family and friends as we know them, in work apron or hair curlers, caught in the act of living.

"In the very structure of the painting," maintained Sharrer, "through the design, form, and color, I try to express this sense of humanity." The Yale-trained painter, who left art school precisely because of its insistence on abstraction, chose the polyptych form, she wrote, because of its historical association with narrative subject matter. In the tradition of American realism, the artist made hundreds of drawings and photographs from life, taking likenesses of family, neighbors, and unknown farmers and industrial workers from the area around Amherst, Massachusetts.

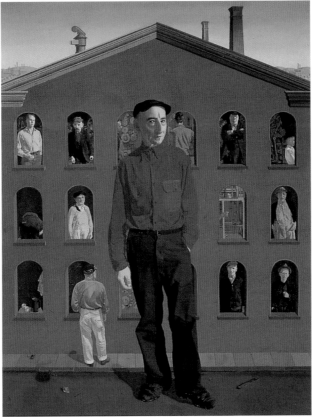

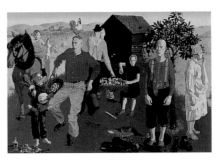

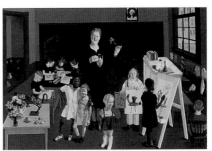

MILLARD SHEETS

1907–1989

Tenement Flats

1934, oil

102.1 x 127.6 cm

Smithsonian

American Art

Museum, Transfer

from the U.S.

Department of the

Interior, National

Park Service

"I'm glad to be alive now," asserted Millard Sheets. "No time was ever so thrilling. This is my age and I love it—the whole works!" The "whole works" included the poverty and unemployment of the Depression, but the California painter captured the cheerful camaraderie of the West Coast urban poor. Bright pink-reds, greens, and yellows ornament geometrically interlocking staircases and terraces of these tenements. Potted plants thrive on a railing as cats observe the activities. Lines of colorful sheets, perhaps a pun on the artist's name, lead diagonally to the three elegant mansions atop a hill. There a lonely figure looks down on the lively society below, where the artist's sympathies doubtless lie. His strong message here is that real life, and happy life, happens in simple environments. One is forced to ask though where the men are in this scene of women and children. At this time of mass unemployment, do they have jobs, or are they out looking, hoping for a day's wages to feed their families at home?

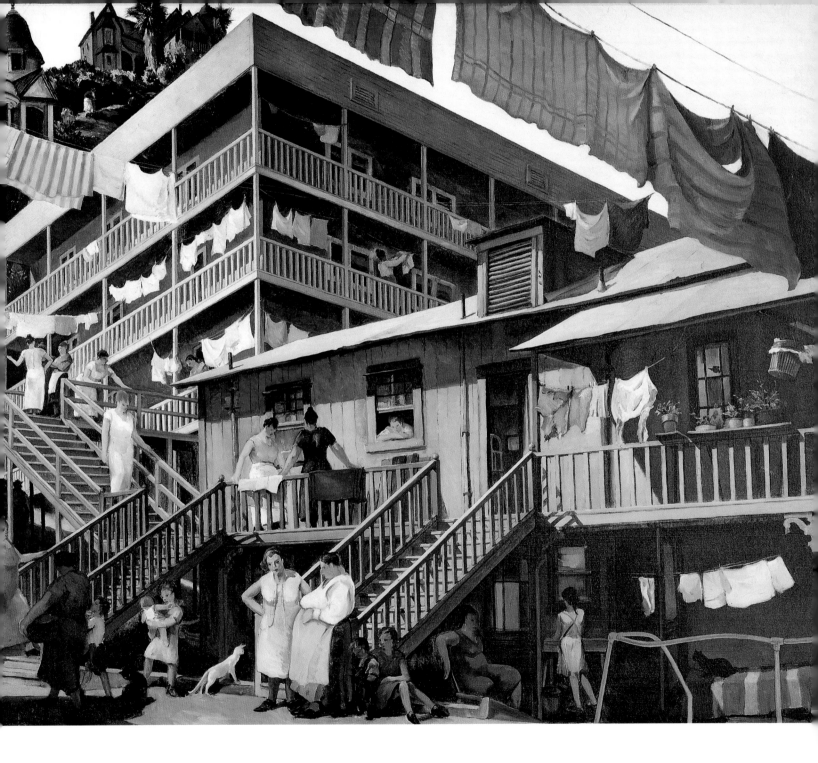

JOHN SLOAN

1871–1951

Travelling Carnival, Santa Fe

1924, oil
76.5 x 91.6 cm
Smithsonian
American Art
Museum, Gift of
Mrs. Cyrus
McCormick

Two circular forces dominate this raucous traveling carnival: the revolving carousel and the spinning Ferris wheel. Against the dark blue sky the electric illumination of the rides seems even more lurid and exciting. The populous scene must have fascinated Sloan, known for his pictures of busy urban centers such as New York City. The artist and his wife visited Santa Fe for the first time in 1919 and returned almost every year for the next thirty years. Traveling carnivals would stop in the town, and the carousel, with its motley horses, was always a central part of the festivities. A survey of the crowd reveals the mix of types in the town, from cowboys and trendy young girls to the Spanish women in black shawls. Finally, like a symbol of all that is daring and fun, a woman in pink reclines backward on her galloping steed as the carousel spins on into the velvety southwestern night.

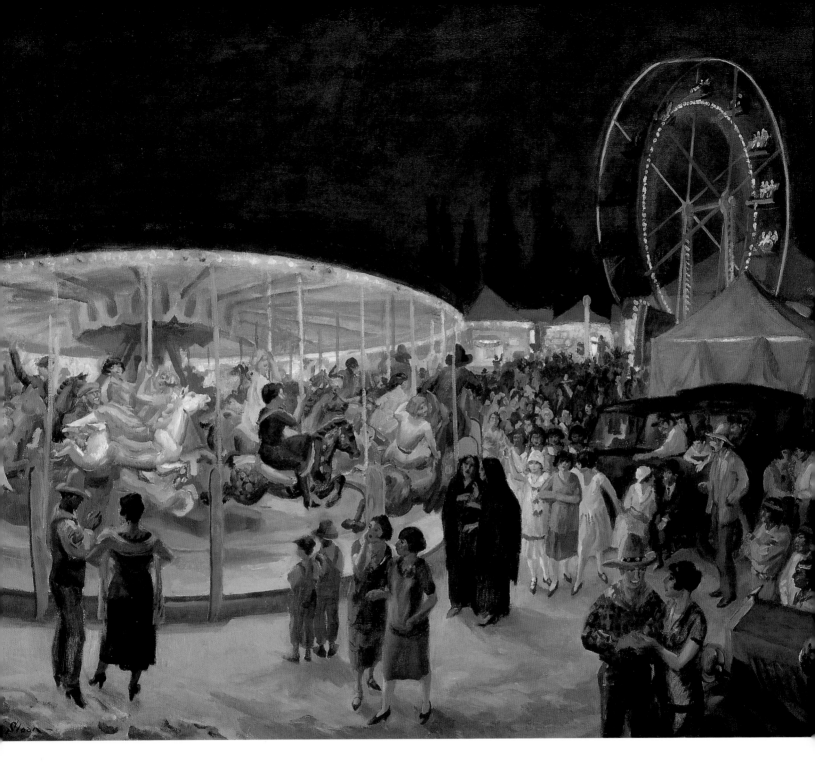

MOSES SOYER

1899–1974

Artists on WPA

1935, oil
91.7 x 107 cm
Smithsonian
American Art
Museum, Gift of
Mr. and Mrs.
Moses Soyer

Six artists gather in Soyer's communal studio. Both the individuals and the space were sponsored by the Works Progress Administration, a federal agency that funded artistic projects and provided a living wage to artists during the Depression. Around the periphery of the room, Soyer's assistants transfer to canvas his designs for a group of portable murals on the theme of children at play that were commissioned by the WPA and installed in schools and libraries. The colorful, monumental canvases take shape in a mood of seriousness as Soyer illustrates the profound import of the artist's profession.

Artists on WPA vividly demonstrates the progressive attitude of President Roosevelt's administration. In Soyer's own words, "the WPA art project has given dignity to the artists. It gave them a feeling of belonging, of being useful members of society. They worked with enthusiasm and have produced fine work in many media. . . . It was a fine and hopeful period for American art."

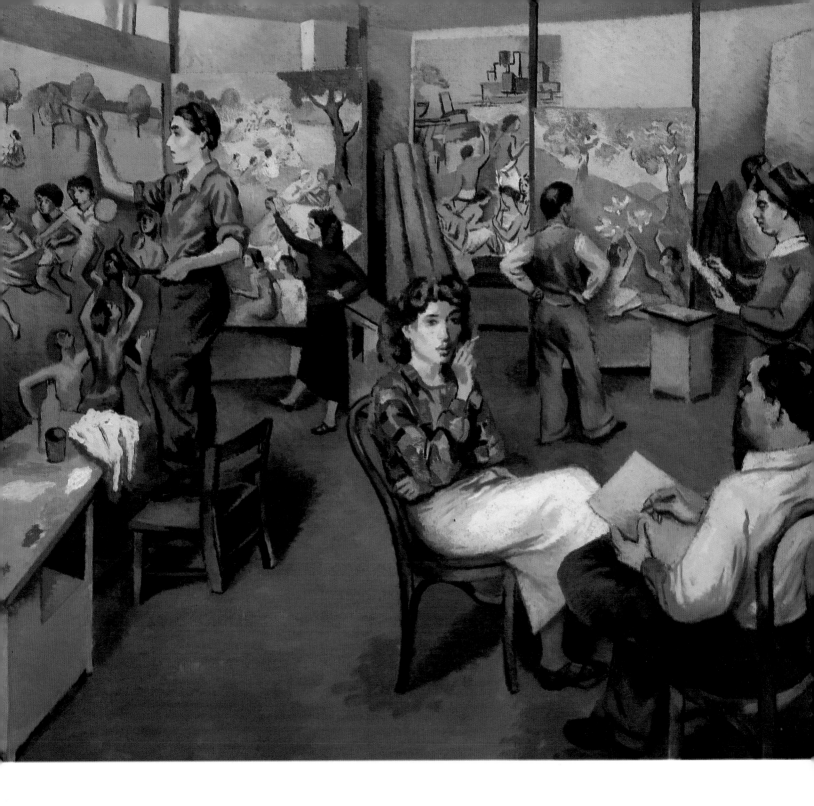

RAPHAEL SOYER

1899–1987

Annunciation

1980, oil
142.5 x 127.3 cm
Smithsonian
American Art
Museum, Gift of
the Sara Roby
Foundation

Raphael Soyer painted *Annunciation* when he was eighty-one years old. A poetic harmony of blue and violet hues, freely brushed, the image depicts two young women standing near a wall sink. Although they do not speak, an intense message emanates from the eyes of the girl at right. Through the title, Soyer casts her role as that of the angel who announces to Mary that she would bear the Messiah. The other woman holds a white cloth reverentially in her hands; along with the water that would come from the sink, the cloth traditionally refers to the purity of the Virgin. In the absence of an explicit narrative, however, we can only conclude that this private interaction between two modern women may be a simple and timeless announcement of an impending birth, conveying the mystery of life and regeneration.

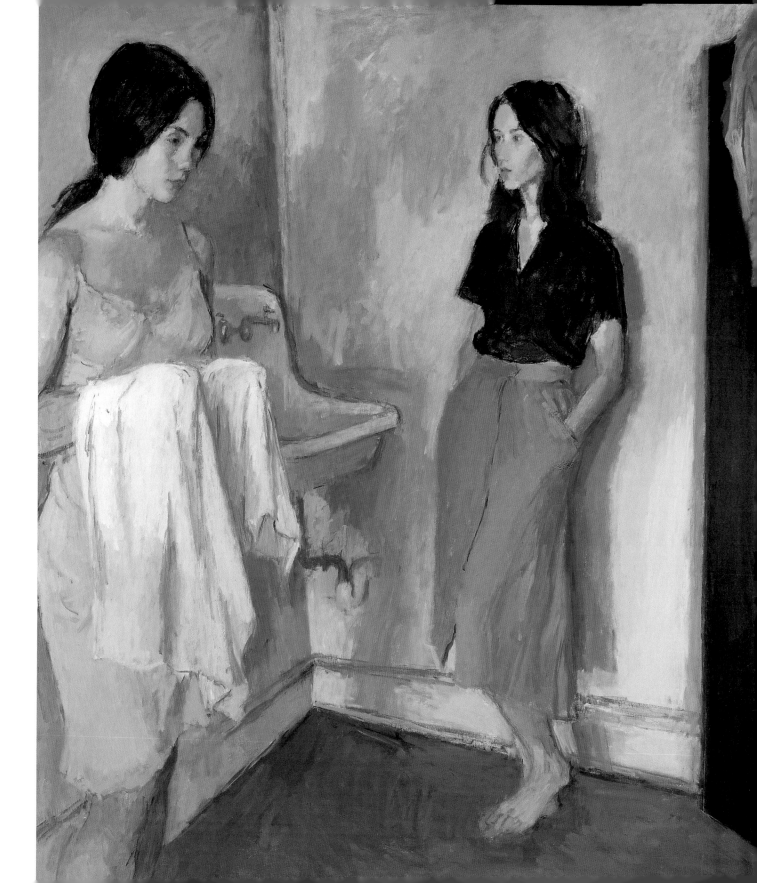

RAY STRONG

born 1905

Golden Gate Bridge

1934, oil
112 x 182.3 cm
Smithsonian
American Art
Museum, Transfer
from the U.S.
Department of the
Interior, National
Park Service

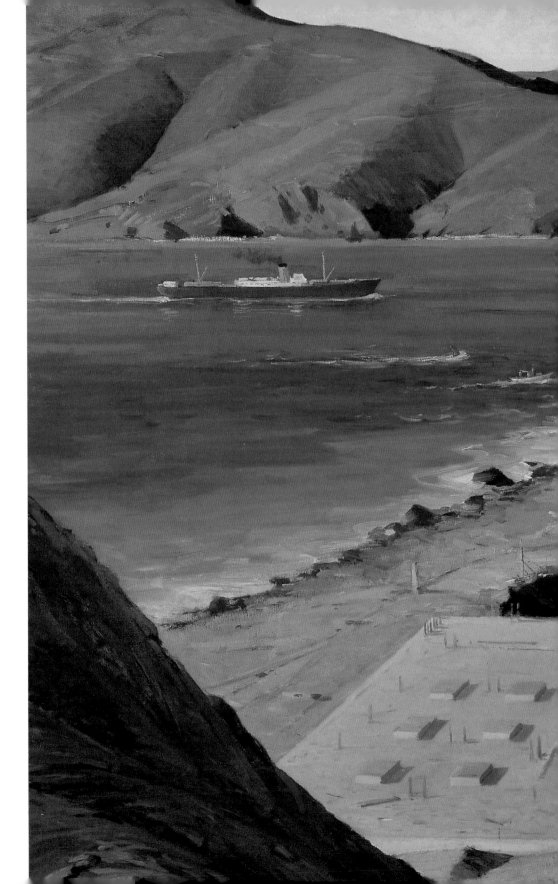

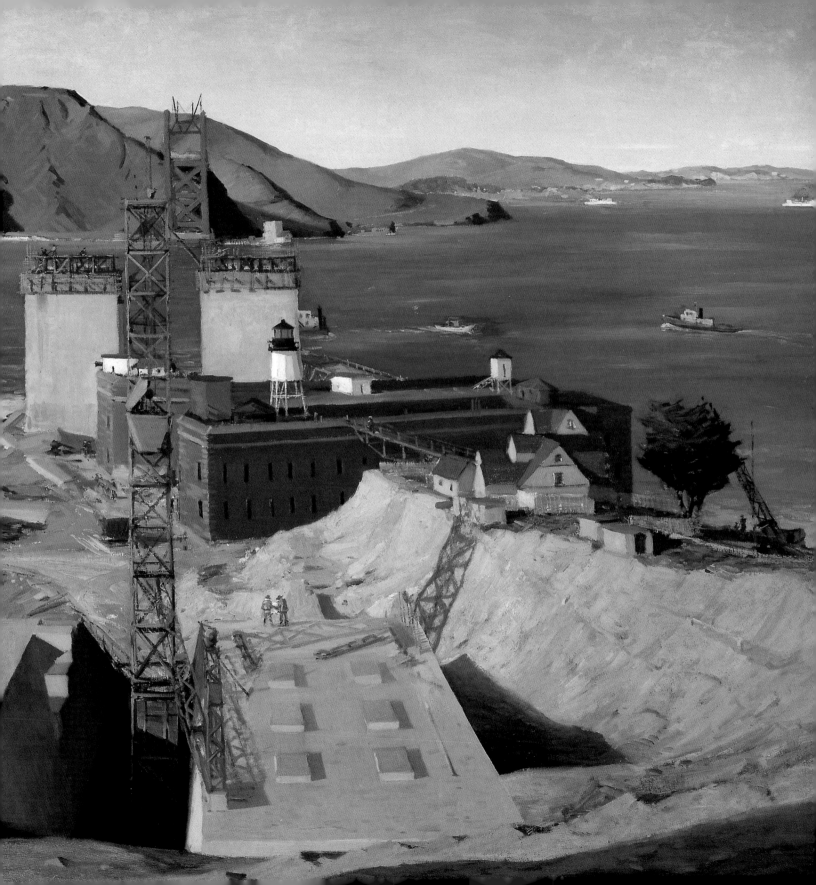

AGNES TAIT

1894–1981

Skating in Central Park

1934, oil
85.8 x 121.8 cm
Smithsonian
American Art
Museum, Transfer
from the U.S.
Department of
Labor

Tait was deeply grateful to the federal Public Works of Art Project, which commissioned her to paint an American scene for a public place. She was thrilled to create, in her words, "a large decorative landscape of Central Park . . . a large skating pond against the background of large buildings seen in the late afternoon light. Fortunately, the recent snows have afforded the effects I was seeking. In the foreground I plan many detailed figures of skaters and children at play."

The lively image depicts a winter paradise and the sharp, fresh clarity of a winter's day in the city. New York's grand skyscrapers take second place to nature as city dwellers delight in the country pleasures of skating and sledding in Manhattan's most important public park. The artist was indebted not only to the linear simplicity of American folk art, but also to the animated figures in works by the sixteenth-century Netherlandish landscape painter Pieter Bruegel the Elder. With its decorative and rhythmic pattern and geometry, *Skating in Central Park* reveals the artist's direct yet sophisticated approach.

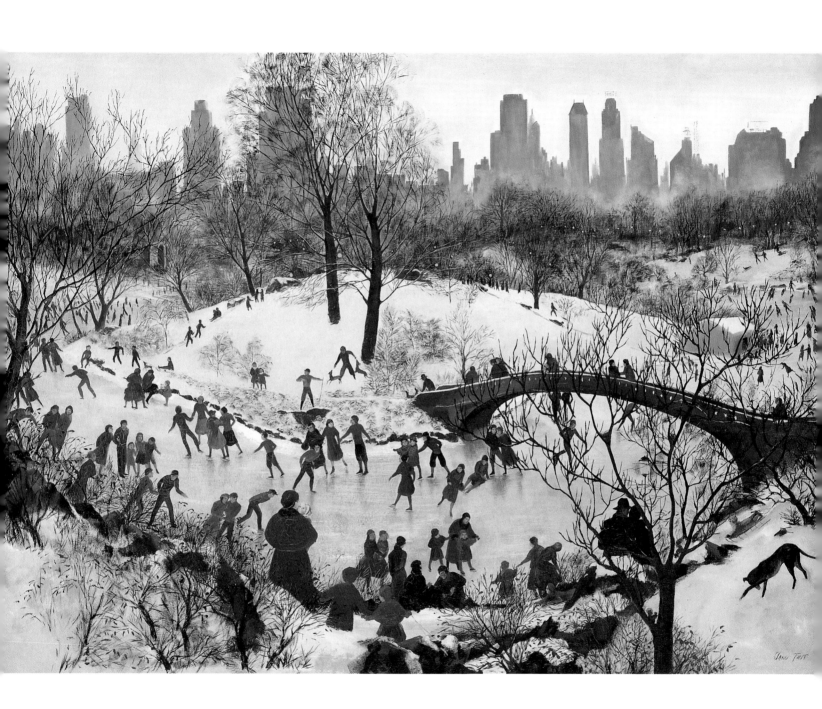

GEORGE TOOKER

born 1920

The Waiting Room

1959, egg tempera
61 x 76.2 cm
Smithsonian
American Art
Museum, Gift of
S. C. Johnson
& Son, Inc.

Endless rows of cold fluorescent lights illuminate numbered open cubicles where men and women stand, sit, read, doze, and hold each other in silent desperation. The scene is suffused with a feeling of hopeless resignation; we have no idea for how long, or even why these people wait. In one stall, a grinning face on a magazine cover obliterates the reader behind it; in another, limp coats hang from hooks, suggesting departed occupants. There is no sense of how many cubicles there might be in this anonymous space—the repetition is chilling. Muted icy blues punctuated by startling red and pink accents heighten the charged atmosphere, as does a sinister figure with a hat pulled low over his eyes who stares at us from behind blank lenses. The artist makes the familiar seem unfamiliar, evoking the uncertainty of an alienated, mechanized society and the isolation of modern existence.

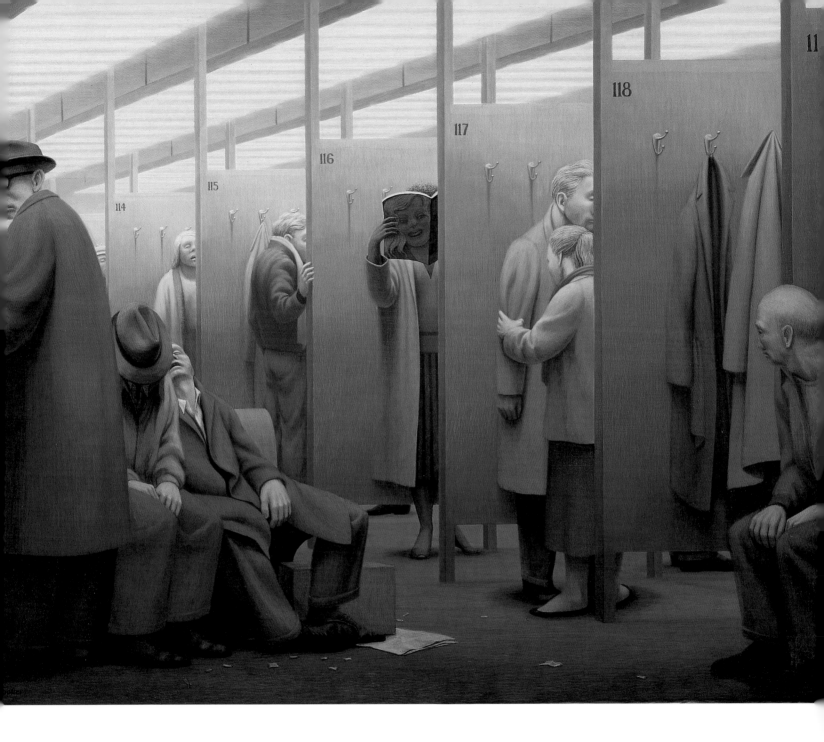

ROBERT VICKREY

born 1926

Fear

1954, egg tempera
87 x 148 cm
Smithsonian
American Art
Museum, Gift of
the Sara Roby
Foundation

Arms flung wide in desperation, a nun halts in her tracks as she reaches an impasse where the grassy park ends and the empty desert of brown soil stretches before her in every direction. We see her from the back, her head concealed within an extravagant coif with its grand wingspan—a religious figure wandering in an alien contemporary landscape.

In the 1950s, when abstract painting dominated the art world (perhaps symbolized by the aridly rectilinear architecture), Vickrey delighted in detailing every blade of grass. The delicate medium of egg tempera, where each layer of paint glimmers, enhances the magical quality of Vickrey's realism. Although his imagery is dreamlike and cinematic, betraying his passion for movies, the artist denies that his paintings narrate specific stories. He is more interested, he maintains, in creating a mood. The artist described this mesmerizing composition simply as "the image of a nun fleeing the rubble and erosion of contemporary civilization."

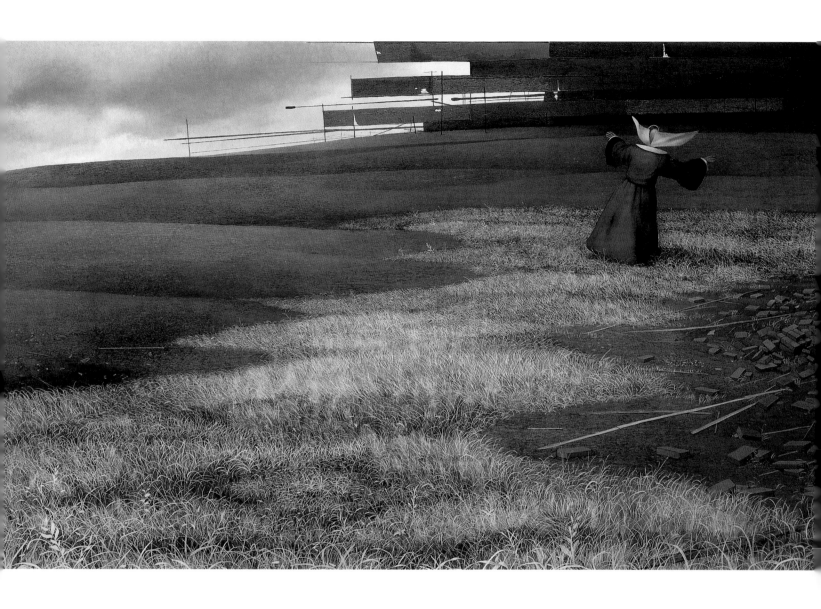

GRANT WOOD

1891–1942

Landscape

1930, oil
32.1 x 37.2 cm
Smithsonian
American Art
Museum, Gift of
Park and Phyllis
Rinard

Wood's two-sided painting has a landscape on the front and an old house—a study for the one that appears in his famous work, *American Gothic*—on the back. Interestingly, although the artist was considered a regionalist painter and quintessentially American, one of the most important sources for his work was Chinese art. Wood never forgot his mother's set of the "Blue Willow" china pattern found in so many American households. Elements of that pattern emerge here in the composition's curves and interlocking designs. In its expressionistic exuberance, the painting exposes a less-known aspect of Wood's art.

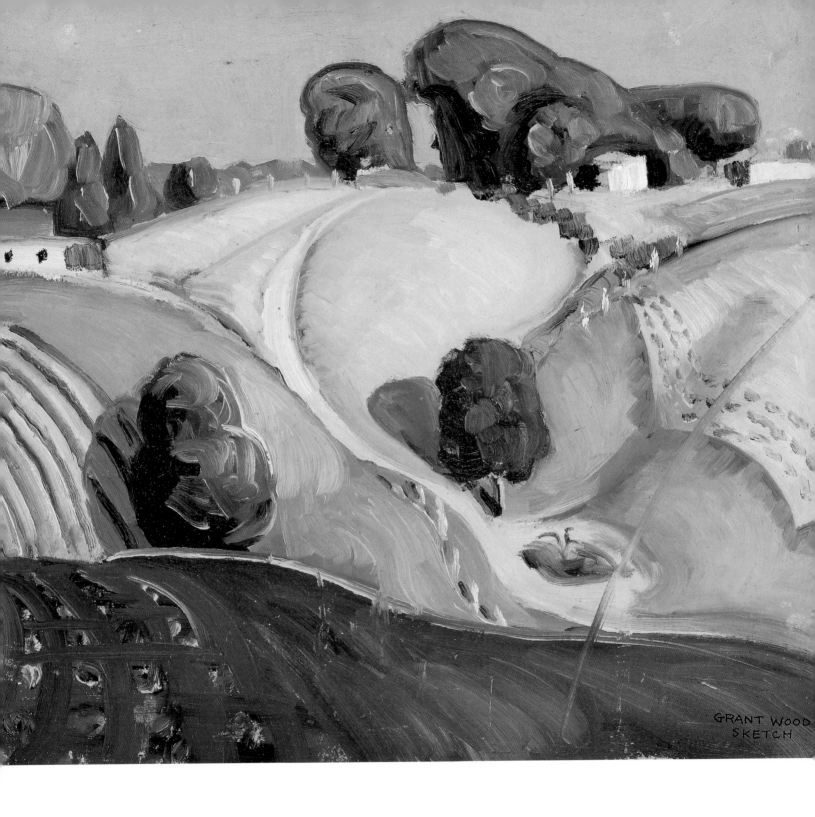

GRANT WOOD
SKETCH

ANDREW WYETH

born 1917

Dodges Ridge

1947, egg tempera
104.5 x 122.3 cm
Smithsonian
American Art
Museum, Gift of
S. C. Johnson &
Son, Inc.

Windswept, barren, an epic of land and sky, *Dodges Ridge* overwhelms us with the power of God's nature. Wyeth's delicate calligraphic grasses in muted browns and greens contrast with the broadly brushed dynamism of racing gray clouds. A tilted stake, made cruciform by the crossbar, stands firm against the wind. Along with the tractor grooves it reveals the presence of humankind in the wild landscape. According to the artist, it is "not a scarecrow in the picture. It is a tattered shirt on a cross pole to scare [seagulls] away from the blueberry fields. This was painted in the late fall after the blueberries had been raked." But the religious symbolism of this theatrical device and the harvest theme suggest a deeper meaning, perhaps the accidental death in 1945 of the painter's father, the illustrator N. C. Wyeth, which was a turning point in his son's life.

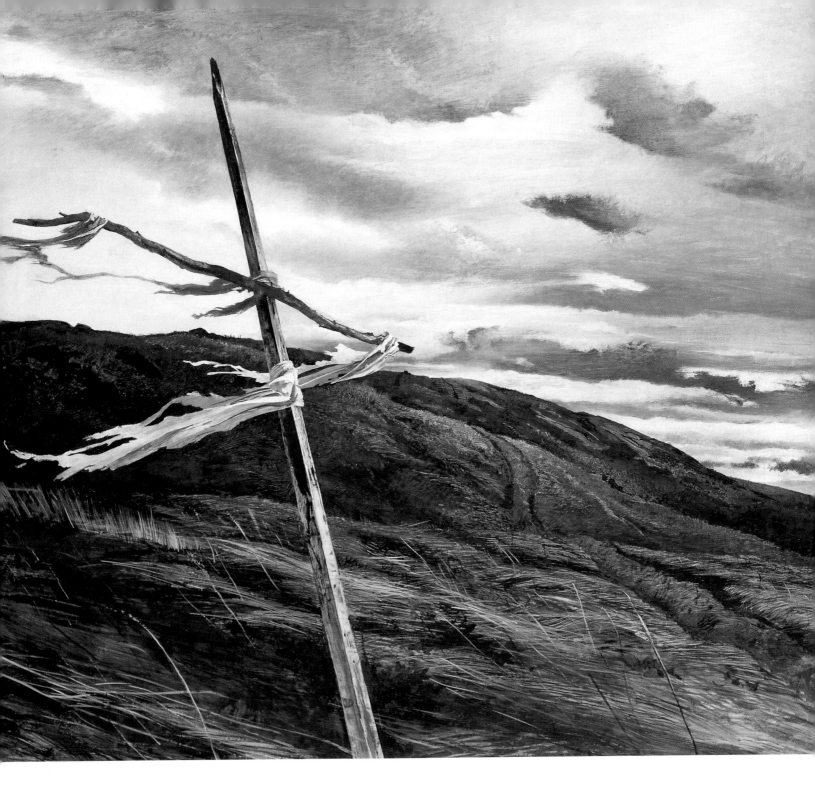

Index of Titles

Annunciation, Raphael Soyer, 96

Artists on WPA, Moses Soyer, 94

Aspects of Suburban Life: Golf, Paul Cadmus, 14

Automotive Industry, Marvin Beerbohm, 8

Baseball at Night, Morris Kantor, 58

Beach Umbrellas at Blue Point,
William Glackens, 40

Brownstone, Harvey Dinnerstein, 32

Buffalo Grain Elevators, Ralston Crawford, 20

Can Fire in the Park, Beauford Delaney, 26

Cape Cod Morning, Edward Hopper, 50

Construction of the Dam, William Gropper, 44

Dodges Ridge, Andrew Wyeth, 108

Double Portrait of the Artist in Time,
Helen Lundeberg, 68

Dust Bowl, Alexandre Hogue, 48

Early Morning Work, William H. Johnson, 54

Employment of Negroes in Agriculture,
Earle Richardson, 82

The Farm, Kenjiro Nomura, 78

Fear, Robert Vickrey, 104

George Tilyou's Steeplechase,
Reginald Marsh, 72

Godly Susan, Roger Medearis, 76

Gold Is Where You Find It, Tyrone Comfort, 18

Golden Gate Bridge, Ray Strong, 98

Harlem Dancers, Margaret Brassler Kane, 56

Homeward, Frank C. Kirk, 62

Island Dock Yard, Karl Fortess, 36

Landscape, Grant Wood, 106

The Library, Jacob Lawrence, 66

Locomotives, Jersey City, Reginald Marsh, 74

Mural of Sports, Joseph Rugolo, 86

Old Black Joe, Horace Pippin, 80

One and Another, Hugo Robus, 84

Paper Workers, Douglass Crockwell, 24

Penn Station at War Time, Joseph Delaney, 28

People in the Sun, Edward Hopper, 52

Playfulness, Paul Manship, 70

Relief Blues, O. Louis Guglielmi, 46

Scenes of American Life (Beach),
Gertrude Goodrich, 42

Skating in Central Park, Agnes Tait, 100

Snow Fields (Winter in the Berkshires),
Rockwell Kent, 60

Strong Woman and Child, Yasuo Kuniyoshi, 64

Subway, Lily Furedi, 38

Sunlight and Shadow, Allan Rohan Crite, 22

Tenement Flats, Millard Sheets, 90

Travelling Carnival, Santa Fe, John Sloan, 92

Tribute to the American Working People,
Honoré Sharrer, 88

Valley Farms, Ross Dickinson, 30

Vegetable Dinner, Peter Blume, 12

View of the Artist's Home, Pedro Cervantez, 16

The Waiting Room, George Tooker, 102

Wheat, Thomas Hart Benton, 10

Woman at the Piano, Philip Evergood, 34